ON VALENCIA STREET
POEMS & EPHEMERA

JACK MICHELINE

EDITED WITH AN AFTERWORD BY TATE SWINDELL

INTRODUCTION BY ERIC MINGUS

LITHIC PRESS
FRUITA, COLORADO

ON VALENCIA STREET: POEMS & EPHEMERA
JACK MICHELINE
ISBN 978-1946-583123
Lithic Press

LITHIC PRESS
fine books for an old planet

www.lithicpress.com

For steve dalachinsky and Robert Parker Kaufman

CONTENTS

INTRODUCTION

Well here is it again Jack
You out of the blue
When I near forgot myself
You spewing it out loud from beyond
Shaking loose the forgotten bits and pieces

This is how I know you

Popping in and out when you see fit to shake my ass up
Rewiring my loose connections
Strolling up to our street side table
to catch a chat with my dad
and to dazzle my fresh mind with words
connecting in ways I never knew they could
a few more times after that

Then you fell from my memory
only to reconnect one flight up in a Brooklyn brownstone
Swapping poetry like gun slingers and lovers
encouraging and laughing
pointing me in directions I feared go
My streets were newer than yours
Now they are older and even more distant
ruled by drugstores and banks
But your whispers
cut through that shit scent most folks
don't catch as they go about their day

When I read Jack's words or look at his art, he is very much present. I hear his voice as I read, practically see his hand drawing when I see the sketches. The flyers place me back in the audience way back when waiting for Jack to take the stage.

This collection is fascinating and unique. Those of us who knew Jack, get to see a broader view of his work. Perhaps a side we did not know. An affirmation of his devotion to being a poet of the streets. All at once he pisses me off, breaks my heart and brings me joy.

For those of you who are new to the fold, this is a great collection. Jack speaks beautifully, loudly, softly, ugly, dirty and clean from these pages. The full measure. He works his craft and is never afraid to show his vulnerability. The ephemera gives a great glimpse of his art and a glimpse into his life's timeline.

Whenever I was with Jack, I was protective of him. Pointless really. He would just dart off in the opposite direction we were headed. I would try to wrangle him in. Sometimes it worked, mostly it didn't. We always ended up doing something unexpected, different from what was planned. Sometimes fun. Sometimes terrifying. But we always ventured forth with love and joy.

–Eric Mingus

On Valencia Street
Poems & Ephemera

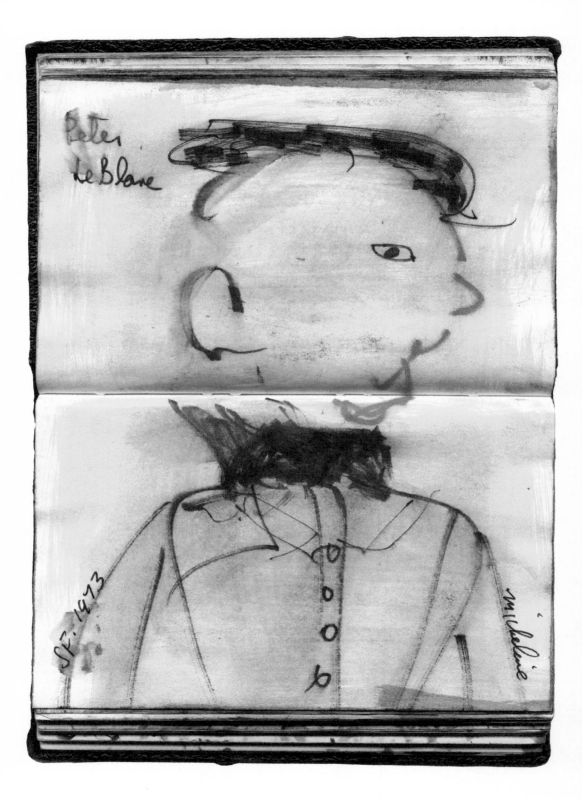

THE ACE OF SPADES

He didn't mean to do it
but he had to
crashing thru the door
out of his mother fucking head
with pain
and flowers
and genius
and frustration

It would make
the morning paper
and he would be
in the nut house
or
dead
in the morning

The
child
stand upon
a hill
the
nursery

flower
for
all
to
sees

madeline 71

14

WALK WITH ME

Walk with me
Take my hand
See the sky
Feel the sand

Don't say a word
Speak with your eyes
We are one
When we're together

Walk with me
I see the sun
Touch your toes
The moon in your eyes
When we're together

Children running, skipping, laughing
flying thru the years of sand
wiggling toes into the softness

NOTE BOOK

OF

POET- PainTer

Jack Micheline

July 1993

BALTiMoRE Md.

This vo To book
was started
i Baltimore Md
July 1993
and finished
in Sacramento
Calif
Sep 2, 1994

THE GEEK

He needed the blows and he didn't know why
He needed the whip up his ass
The wind in his face
He needed the movement
The action
He was tired of looking at it without response
Talking was not his game
For life is not a game
He needed the blows
To take on the world
Like a true poet

PROCEEDS TO FIGHT CENSORSHIP IN AMERICA admission $1

taylor mead

jack micheline

bernie uronovitz

3

REBEL

MONDAY, JULY 1 • 9 pm

POETS

The Living Theatre • 530 Sixth Ave

NOTES ON A MONDAY NIGHT

I stared at the building
the box shaped building
flat and empty like our own souls

Footsteps walked upon the earth
the pavements of the cities
that seem naked of realness
and naked of saints

Tonight
the world seems empty
very cold and empty

Seeking the friendship of strangers
seeking a new face
a new smile
a fresh rose
look up—look up
it is better to look up than look down

Fear will cover the rose
before it blooms
blooms on these quiet days of rare solitude
that seem to float in the air of buildings
on these quiet days, so rare

The fiery sun is gone
but then it will come back
life is made for the doers
life is made for the doers

There is so much death in the tongues of men
in the impressions of the false
there is death in words overdone
tongues caught and choked by words
there is death

there is death
in the city
in the bars
on such a beautiful night
there is death here
as I sit at the bar
there is death tonight
this Monday night
there is death here
in the mouths of men and the stomachs of women
there is talk in the cities

Those real men, the burning men,
who are only themselves, inhabitants of the lost earth
Above the rock, the angel faces smile, above the nothing waste of man
Man can never destroy the beauty
but he tries
covers it with darkness
he denies it

We live in an alien land
with alien ways
where men pursue the ways of animals
in this jungle
in this house of refuge
accept it or deny it

The world moves on
the earth moves on to find new ways
the colored lights
the shades
the rainbow pavements
the darkness of night
the prison of the minds

Beneath the curiousness of strangers
kindness does not look down upon men
desire above the empty hollow shell
shells dug in the sands
fear is the enemy of man
fear and the ways of fear

Give me the animal midnight
shrieking beneath the flesh
where the blood flows like the river
let the torrent run over
when the mind can rest and breathe
round about ways
so unclear
zigzag like the puppy
sheltered
imprisoned in the animal darkness
music flows in the spirits of color
crippled men stagger
calm water beneath a living fire

Maybe there is a knowing
a sense far greater
far more deeper than the sense of the just

or the material search
for it is the knowing within us
a sense of contact indefinable
that holds all the riches
the true riches of man

THE GUYS ON THE RAIL

You never seen a finer bunch of losers in your life.
Benny was short, wide and round and looked like one of The Three Stooges.
Zulu wore a green bowler hat he was tall and graceful most of his
teeth were missing. During the Depression he worked as a street
singer he used his powerful lungs to cheer his horses on.
Koffie was already nuts a pure optimist he would bet on anything
with four legs. He had given up a long time ago and the action was
the only thing he had left.
If the Ritz brothers and The Three Stooges came out of their graves
they would be identical twins.
Jack was a numbers player he believed in intuition and dreams.

They all read the racing form and played the big six.
The dream to win 25,000 dollars on a two-dollar bet.
It all had to do with the love of horses and the desire to win and the
need of action. Always the odds are against the horseplayer.
Especially when there are ten or more horses in the race.
The odds didn't mean a thing it was the race that counted.

Benny, Koffie and Zulu worked for the DeLeon cab company.
Taxi drivers are independent people by nature.
They like to be their own boss.
They worked this all night.
Since they all had a streak of individuality and dreams.
They loved horses more than women.
Their dream was to win big,
to be a big winner,
and to say the last win was a rare occasion.
The dream of every horseplayer,
was to leave the track with a bag full of money.
If they would lose, as it happened, most often they lost together.

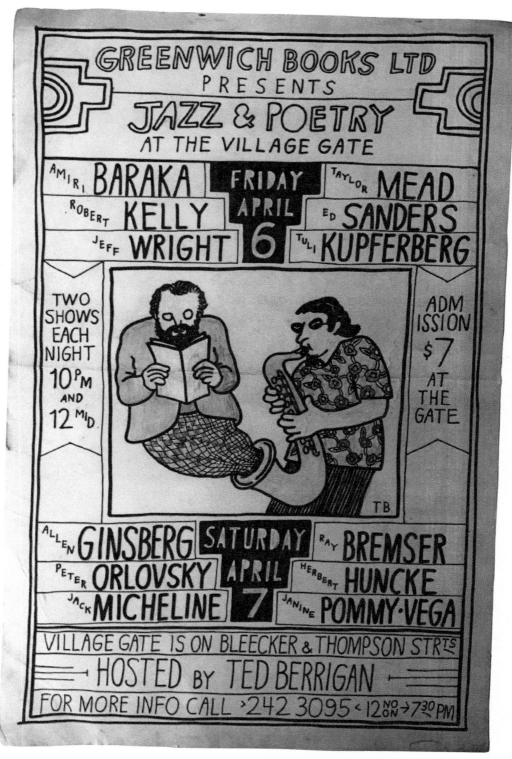

GREENWICH BOOKS LTD
PRESENTS
JAZZ & POETRY
AT THE VILLAGE GATE

AMIRI BARAKA · FRIDAY APRIL 6 · TAYLOR MEAD
ROBERT KELLY · ED SANDERS
JEFF WRIGHT · TULI KUPFERBERG

TWO SHOWS EACH NIGHT 10 PM AND 12 MID.

ADMISSION $7 AT THE GATE

ALLEN GINSBERG · SATURDAY APRIL 7 · RAY BREMSER
PETER ORLOVSKY · HERBERT HUNCKE
JACK MICHELINE · JANINE POMMY·VEGA

VILLAGE GATE IS ON BLEECKER & THOMPSON STRTS
HOSTED BY TED BERRIGAN
FOR MORE INFO CALL ›242 3095‹ 12 NOON → 7³⁰ PM

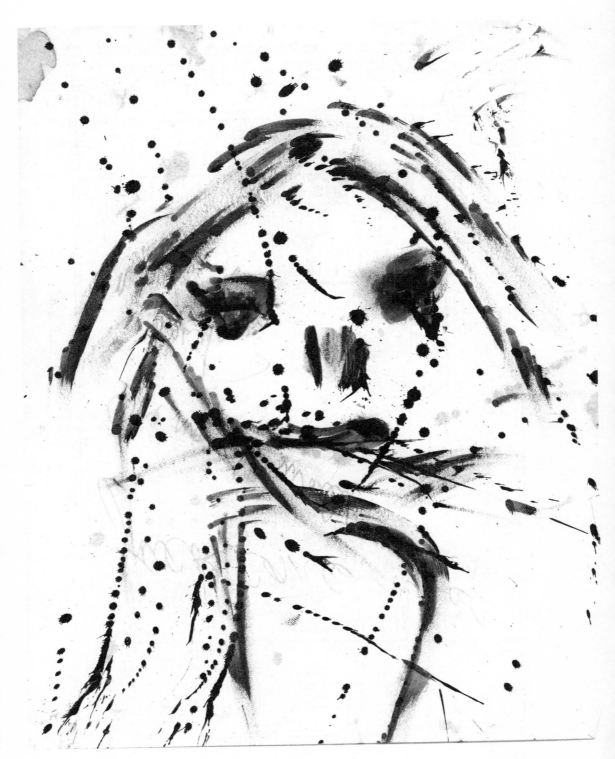

WHAT ELSE IS THERE

What else is there
But to encourage another freak
I have nothing to prove
Not even to the mountains
Famous men are boring
And girls on buses are scared

Hope, faith, a pale sky above me
Will affirm this cautionary tale
Chased by dreams of my childhood
Across boundaries and jungle of cities
To leave nothing but the wind behind
To conjure up a brick
Like a magician to sunrise
To hustle poems and paintings
To middle age catholic girls
Who believe in saints

I wander through the neon cities
And laugh at the sun
Amid the inhabitants of these cities
Amidst its pain and shrill cries
I will raise my hand
And do my mad wild dance
And will die

A WHORE, WALT WHITMAN, A POET AND GOD

I met a whore in front of a forty-second street movie
She asked me who I was
I told her I was a poet
And I had eight cents
She paid my way into the movies
Walt Whitman sat on one side of me
And God sat on the side of the girl

I told her we were here because we had no teeth
I put my hand up her dress
Touching her bare thighs
And Walt Whitman smiled
We made love in the movies

After the movie
She took me to a waterfront hotel
My white body above her black soul
Our naked bodies joined in unison
We cried in each other's arms
And God smiled
We had no teeth
And I was humble and meek for the first time

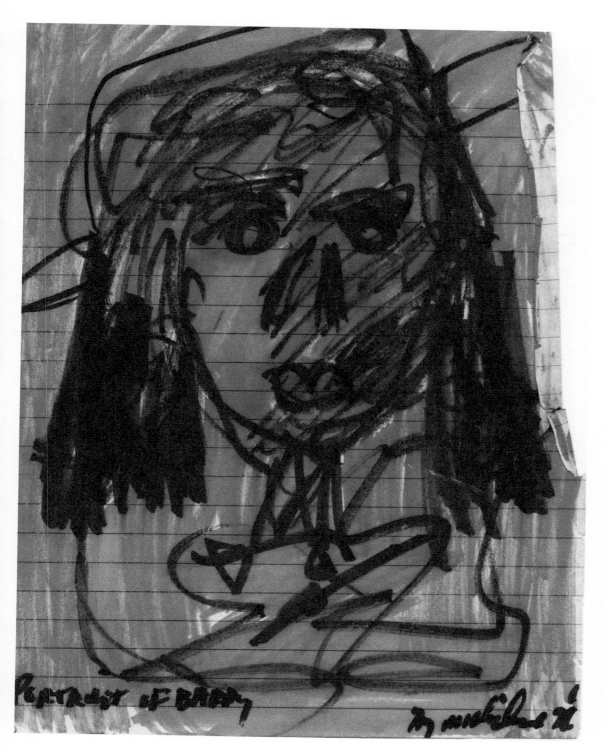

Portrait of Barry

27

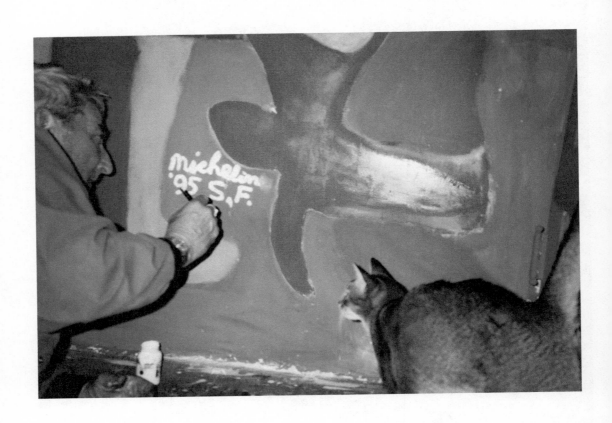

ON VALENCIA STREET

In my neighborhood it is 11 P.M.
A lady gives out flowers to the poor
Winter is coming
On a quiet Monday night after a thanksgiving holiday
Everyday the beggars sit on milk crates

 pushers, pimps
 punks, parasites
 homeless, hawkers
 hustlers, predators

Among the poor and the damned
The preachers hide in the churches
The publishers could not raise the money

 to print my book

I almost died of diabetes this year
After my hernia operation
Few people came to my hotel
To visit the poet of the streets

In the museums they honor the beat generation
The rich and the poor will all die broke
We will all go naked to our maker
The honorable mayor gets a speech printed in the Mission News
The moon shines on the concrete city
Scott hung my painting of poet Bob Kaufman
At the Uptown Bar on Capp Street
I painted a mural in the back room
Of the Abandoned Planet Book Shop
On Valencia Street

I AM A POET

I am a poet
I am an angel
I am a thief
I am a beggar
I write my poems with blood
my head seems heavy now
I am able to laugh
I am able to cry
I am serious about life
I am frantic about life
I live in a very immediate state
I cannot earn a living
I go on the streets and beg for money
because money makes one rotten
because money buys eggs
because money is what everybody asks for
because money has driven me mad

I am a poet
I am a beggar
I am a thief
I live like the lowest form of all life
I am a real poet and that is rare
yet people run away from the real
yet people's faces I see are very sad
because they always want more
because they are not happy
because they think security is life
because they think they are realists
because they think they are practical
like business men are practical

I have touched the leaves of trees
I have seen a field of wheat in the grass
I have seen light in the darkest night

I have felt the air of poetry
I have remembered one sentence
that cannot be taught at any university of learning
that was the key to my life
I have run wild in streets
I have died many times
I have been by the rocky shores

this world I live in kills poets
this world I live in is insane
this life that I live is real
I am a poet
I am a real poet
I beg for money in the streets like a dog
like the lowest animal

death is always alone
death is lonely and sad
death is misery
death always seeks more misery
death denies their own death
death denies all living things
death has the power to defy death
death is unable to love
death is enclosed in bank vaults
death is fear and armaments
death is taught at universities
death has never loved
because fear teaches at the university of all learning

I am a poet
I am an angel
I am a thief
I am a beggar

love will save us
love will defy death
love will cut the bonds of birth

I read my poems to the moon and howl
I sit down on the curb and cry and defy all madness
I defy the murderers of all living life
I defy the madness of all civilization

I am a poet
I am a thief
I am an angel
I am a beggar
I write poems with my blood
my head seems heavy now
I shall go on the streets
and beg for money
like the lowest animal

JACK MICHELINE

A Poet from the Beatnik Generation Reading His Work

TRIBUTE TO LIFE

One skinny
old man
standing
against a wall
playing one note
on a harmonica at noon
sounds better
than all the bands
in the world
One skinny
old man

Jack Micheline

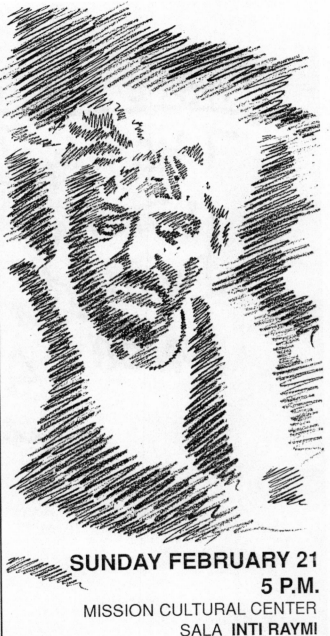

SUNDAY FEBRUARY 21
5 P.M.
MISSION CULTURAL CENTER
SALA **INTI RAYMI**

Sponsor By Editores Unidos Salvadoreños & M.C.C.

YOU ASKED IF I LIKE TO LAUGH

You asked if I like to laugh
sometimes I laugh my balls off
sometimes I smile
sometimes I talk to the stars
sometimes I talk to the moon
sometimes I don't laugh
sometimes I talk to the birds
sometimes I am ridiculous
sometimes the world is screwy
I like to laugh sometimes

THE POEM

The poem
was an eye
of its own
the poet
merely its
messenger
of spirit

From a poem painting
NYC, 1963

MICHELINE'S VISION

That man love unashamed and freely
That each person, man, woman, flower, dog, child, bird, cat, animal
is sacred and blessed with the providence of being
That destiny like a river flows in stream out of darkness into the light
An endless channel of mankind moving towards the light
At times blind with disbelief, torn by hatred, blind by prejudice and
ignorance he moves onward, wounded, bleeding, misunderstood,
forsaken, paranoid and tortured
He keeps on going regardless of circumstances or consequences out
from the darkness, out into light, back into darkness, out into light
A continuous battle to be one with God and nature
Finding strength in the unbelievable belief that man is beautiful
and life everlasting

Up and down the mountain he goes until finally exhausted,
he collapses groggy with the pain of living,
then renews and rekindles his energy
To go on again spreading his love songs, poems, ballads, stories and
chants to all able to listen in the darkness of cities and towns
This unflinching faith that love triumphs
That light maketh strong and faithful like the wonder of a young child
riding the milky way of dreams
The sun cometh up and then the moon and at dusk
the moment of truth
Light into darkness and then just a flicker of light
Then darkness and after the long night
The sun bright as a sunflower
The process repeating in the endless search of man and woman
for light and beauty in the endless void and darkness
The vast unknown that man walks can also be magnificent
in its glory
The wonder and dreams
A speck of dust a silver of tinsel on the ground looking like
silver mountains of fairyland
A pile of cow dung buzzing with yellow jackets and bees
in the bright sunlight
Blind, groping, and unafraid, man goes on forever in a dream higher
than mountains Beyond the real endless in the eternity of light!

Mannheim
November 30, 1982

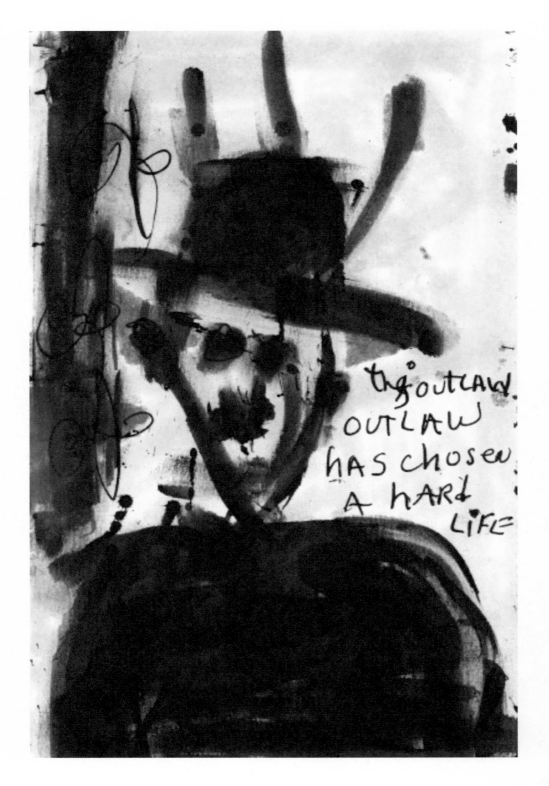

DEATH OF A FATHER

Seymour had cancer. He had lost forty pounds from his shrunken
body. Already he had two operations but it didn't do any good.
He was happy one of his sons had made good and given him a T.V. set
in the hospital.
His other son was a poet, and artist and wanderer who made
very little money.
He hated this son, this poet, because of his individuality and rebellion.
This son had not settled down and made good.
He always told his son, "Why don't you be like everyone else?"

The son could not understand his father. Nor could his father
understand his son. As far as his father was concerned he was a
tramp and a bum, who had wandered across the face of the world in
search of a dream. The other son had proven himself in the world.
He had made money.

Before Seymour died he asked his poet son to show him
some of his paintings.
The son showed his father his paintings and the father replied,
"What stupid fool would buy this shit!?" and turned his head away
from his son.
Seymour had worked hard all his life and his brother was more
successful than him. Seymour was a bitter man.
When the poet son was a child he would leave lights on in the house.
His father would come and shut them off. And this poet son would
put the lights back on again. The poet son seemed to always
put the lights on.
The poet son was not at the hospital when his father died,
early one morning.
He had telephoned the hospital and a woman had told him his father,
Seymour, had died.
The poet banged his fists against the table and cried, and shouted,
ranted and raved like a mad man.
His body shook as the tears poured out of his head.
He did not know his father and his father did not know his son.
And his father was dead.

MANY NIGHTS

He covered me
with a blanket
never said
a word
That
is what
it is about

[UNTITLED...]

People
Die
Because
There
Is
Nobody
To
Love
Them

9/2/88

Dear Jack:
 I liked the Poem, good
you can work thru such a
depression. I still say,
try get advice from John
Murao, Shig's nephew you
native met already long
ago with me Shig at the
Trieste — he's a sensible
kid — & an M.D. I hope
your awareness of the preciousness
of this body keeps you sane +
safe — A body, "free + well favored
difficult to gain, easy to lose: Now
we must do something meaningful" — Love Allen

Jack Micheline
41 Sutter St.
Box 1269
S.F. California
94104

POST CARD

USA 15c

SHIG

He stood there
By the window
And counted time
With his left foot
A hungry poet
Cannot eat pages
He said
Nor sit
At the doorstep
Of the rich
Shig smiles
With his kind eyes
Counting the money
With his right foot

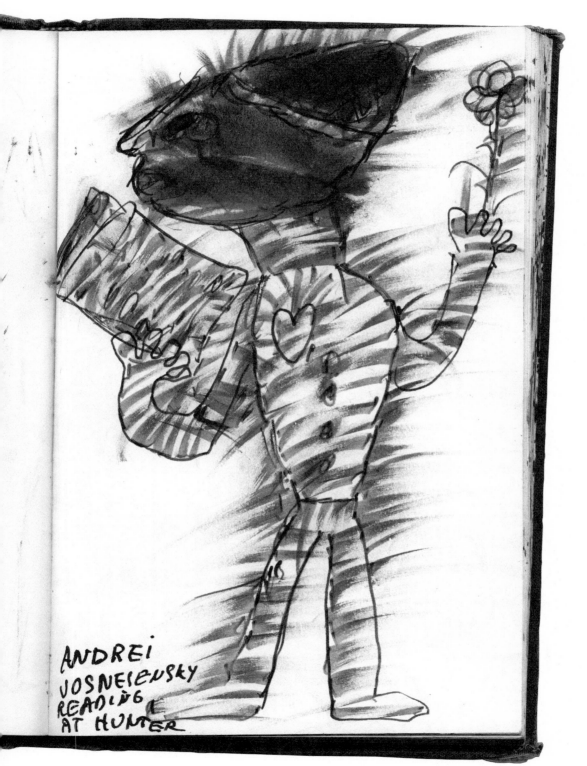

ANDREI
VOSNESENSKY
READING
AT HUNTER

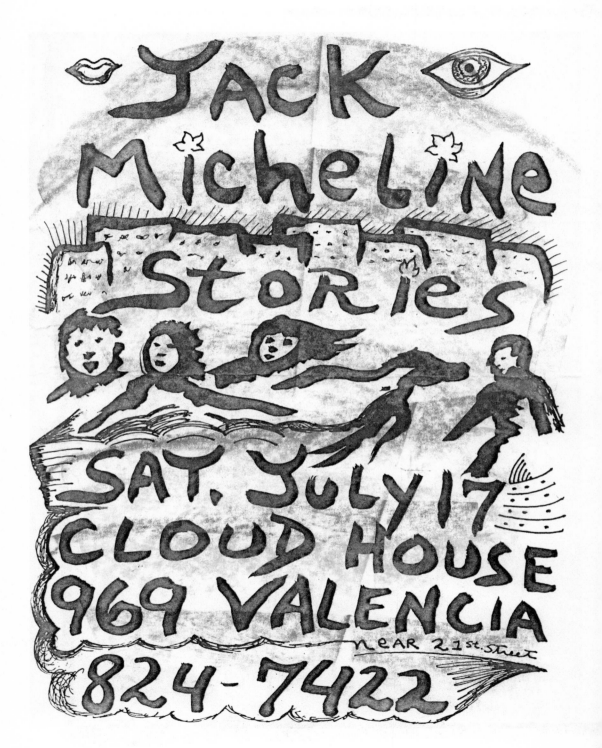

BROOHA MAYAKOVSKY (for KUSH)

Hearing Mayakovsky for the first time
Was like freight trains climbing
And rising over mountains
Deep
Brooding
Intense like Mother Russia
Moving out to the people
In prisons, farms, hamlets, small towns, cities
Across the Volga and the Mississippi
Racing, chugging and moving
Up the mountains to endless eternity
Kruyes Vatchia
Shamayaka
Vesnatcheeia
Broonatchia
Linkabrochia
Yellameya
Mayakovsky
Yellamya
Russia
America

August 24, 1982

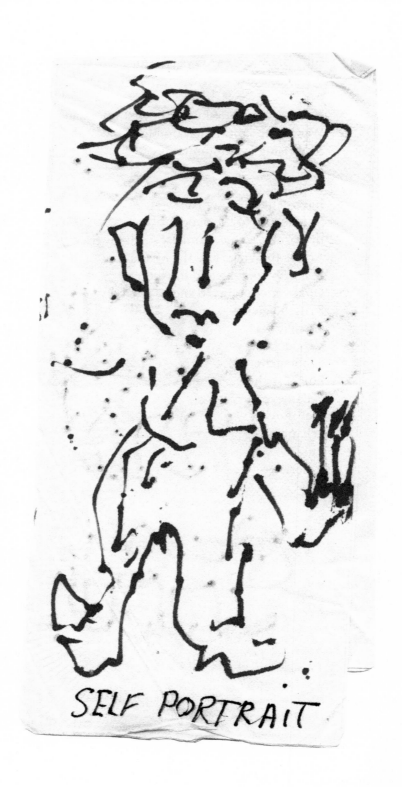

SELF PORTRAIT

STATEMENT OF A YOUNG POET

I was born two pounds, six ounces, and I came out three months too soon from my mother's womb. I've been in a hurry ever since.
I left home when I was fifteen. I have been drunk with life ever since. How I became a writer I don't know. Most of my life has been filled with chaos.
For many years I sought the land of justice and there wasn't any such place. Always I walked in the streets of the city. Always I have been drawn to the people of the depths. Being an outsider myself I naturally felt more at home with the great souls of the real.

I know very little about life. In the frantic state in which I lived, I was always running from one place to another. There is so much mystery to life. I remember walking in the rain three years ago and passing a store with a sign on the door which read Pocket Poets. So I went in and told Brayton Harris I had some poems I had written and he published a book of my poems, "River of Red Wine."
This was a miracle for at the time I did not know I had any talent.
I just wrote because I had to write. Life had been so mad and frantic. I would go from city to city running away from the very demons inside of me. And that was how I got involved with literature.

I was naïve and young and restless, I thought it would be different in the literary world than the other worlds I have lived in. I was horribly mistaken. most of the other young writers I met were not interested in creation. There were no Sherwood Anderson's, Theodore Drieser's, Thomas Wolfe's around. There were very, very few people who were serious about writing. What they sought was fame and money. Very few had soul and the so-called new avant-garde publishers were out to make a buck no matter what junk they shoved into the public eye. It was a mad frantic scramble like lunchtime in the garment center where I used to push a hand truck in the streets.
There were no Maxwell Perkin's around anymore where a young writer could go and ask for advice. I sent some of my earlier work to

Conrad Aiken and he was very kind and suggested that beneath the
dark of myself there was some light.
And I appreciated his warm reply.
As far as poetry goes there is no war in the arts. It is hard enough to
create and anyone who can bring light into this dark age
is really accomplishing quite a bit.
Still I know very little about my craft and I will always be learning
the more I write the better I will get, I hope.

For the last two years I have lived on the streets. Running around
like a maniac trying to spread a little light around in my own little
way. Always I had a notebook with me. And I write on the
curbstones, wrote in the streets, in the cities I've wandered.
Out there in the night were the sounds like joy to my ears. Out there
in the wild and the real. Out there alone the wind against my face.
The demons inside of me driving me from one hell to the next.
Writing in my notebook my notes and poems. I guess I wanted to be
a prose writer but I kept on writing poems. The demons always
calling inside of me. Always I saw light in the darkest places of my
inner soul. Begging on the streets for money at times. Living off the
kindness of friends and strangers. Being drunk with poetry and life.

To be a poet in this age is surely madness. When I was desperate I
used to read my poems in the street and pass the hat. And the plain
working people would throw some coins my way. The kindness and
the warmth of the real people who also lived from day to day and
week to week.

The motors seem to be always racing in America.
This frantic age where people have no time to stop and breathe.
Where the profit motivation kills and destroys almost all
beauty and creation.
Where men sell their souls so easily.
I prefer my madness than living death.
Nothing of any true value can be bought with money.
I prefer my poetry and poverty to the utter futility
of artistic prostitution.

I want to bring some light to this dark age.
The forces of darkness are everywhere.
They attempt to kill all who speak of the soul.
These men in the publishing business
who would sell anything to make a dollar.
Even their own mothers and daughters.
The dark face of greed everywhere in America.
I defy madness.
I defy the darkness.
I shall endeavor to bring hope, light and faith in this dark continent.
I shall endeavor to bring live vital poetry, which has not seen
the light of day yet in America.
Light comes from the very darkness, which I was born into.
The great souls, which I write about, have honored me
with their kindness and warmth.
This is the time to sing and wail!
This is the time of life and live poetry that will bring hope
and light to man.
The future is ahead of us.
The future is ours.
This is my statement to the forces of creation and light.
This is my statement to America.
I, Jack Micheline, affirm life!

50

MAJOR REAGAN'S DAUGHTER

The kid swang a big bat
This is my playhouse she said
I can paint
I can draw
I can dance
I can laugh she said
and most people
can't do nothing
she even drew
number 5 on a funny animal
give me a number I said
and she gave me number five
it won the first race
and I had it to place
paid $33 to win
where was my head
I cannot even play it to win
anytime you meet a kid
called Meghan
believe them

CHARLIE

Charlie was like a wild crazy horse when he drank.
Charlie was from a reservation in North Carolina.
He was born in a lean-to in the woods.
At a very young age he showed an aptitude for music and he was given
a scholarship to the conservatory of music in Hollow Springs
in the Black Mountains.

Charlie had a strange beautiful mind and a rare ability to record
the sounds which entered his mind.
These sounds were called music.
He could not relate like normal, average, ordinary people, so he
wrote it down in musical notes, in scales and meters and breath counts.
He wrote dirges and sonatas and bridges for beats.
Charles was a rare composer.
A man of a rare and unusual talent which is considered to be genius.
All the time Charlie wrote musical notes.

He came to the big city called New York, the apple of the east,
where he lived with his girlfriend Fat Lila in Greenwich Village.
But he was too hard to live with and would use women as quick
as the musical pads he used to write his music on.

To say his life was difficult was an understatement.
Sometimes when Charlie drank too much he would roll in the gutters
and do bird calls in the gutters.
Sometimes he did not remember which bar he was banned from.
It became difficult until after six long months,
he was banned from them all.

The Corner of
North 1st & Bedford

streets marked
the dark corners
on the cobble stone
streets of Brooklyn
shells of neglect
rost and decay
of over ABUNDANCE
mixed with misery
the CRAZed eye
OF A LOST FLAME
the flashing lights
of Manhattan stare
the bridge leaping
cross the river

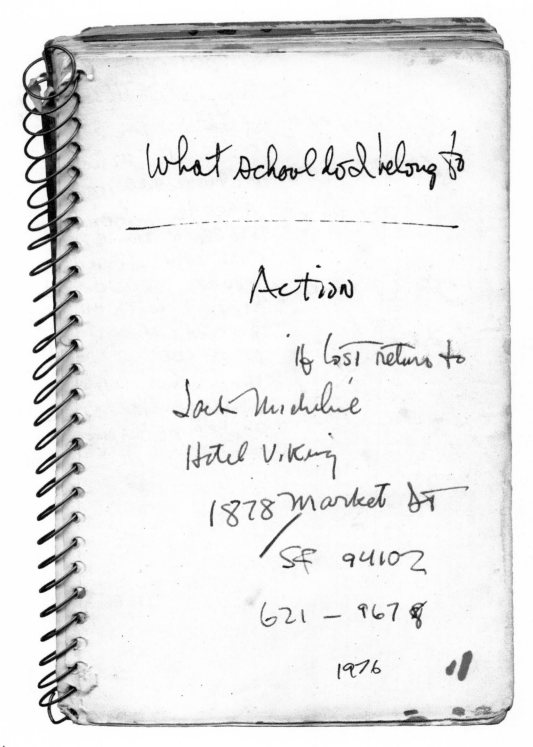

What school do I belong to

Action

If lost return to
Jack Micheline
Hotel Viking
1878 Market St
SF 94102
621 - 9678
1976

COMING OUT OF KEROUAC'S CLOSET

Streets
Cold winter
New York 1961
Wall to wall bars
Desperation
Death
Darkness
The moon lied
The stars
The devil's trap
Streets
Cold Winter
New York 1961
Wanting to believe
Man is good
Man is what he is
Man is a bag of water
A bag of shit
Man is never satisfied

I PROCLAIM MY TRUTH TO A WORLD I WILL NEVER MAKE

I proclaim my truth to a world I will never make
mankind is a whore
piss on the face of death
love death
eat death
drink death
eat the flower of death
I proclaim the truth of full-blooded men

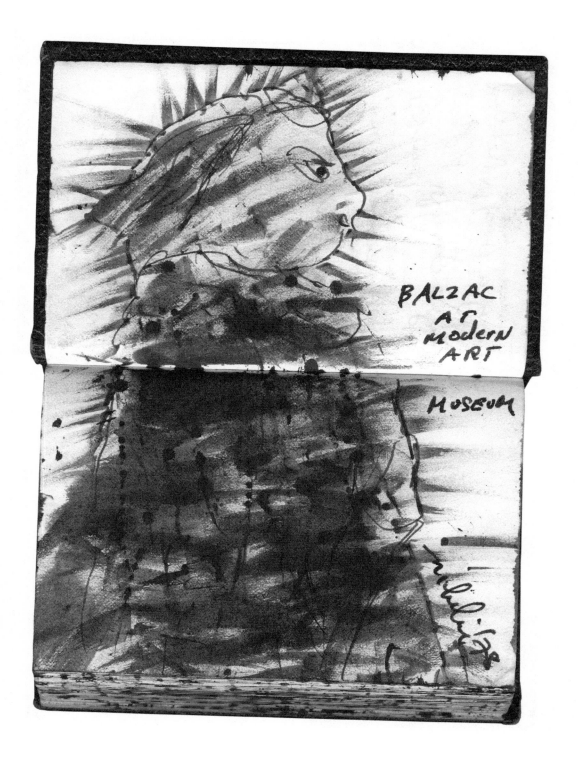

BALZAC
AT
MODERN
ART

MUSEUM

Jack Mikhalen

Man and man kind
like a brother wag
war upon each
other and man
aspires murderous
things. What long and
are the enemy of logic
when slaying hard stones
I long at death and
stone throw its free of death does
its free of death does
& rules & prison

shutting we'll
never be clear
it is filled with
murder & deceit
the chickens will
use up again ?
may they they
believe the fullest

SAGA OF DAN WHITE

Eat a twinkie
Two guys dead
Get off easy
It's San Francisco politics

Moscone was the mayor
Milk was gay
The best politicians
The city did spawn

Dan White was an ex cop
An All-American boy
Hate the ones that are different
The Jews, Gays and Blacks

Dan White was an ex cop
An All-American boy

Freitas was quiet
Norman was limp
Schmidt cried sugar
Diminished defense

Kill Milk and Moscone
For God, Church and State
Cry that you're crazy
And get off with eight

Eat a twinkie
Two guys dead
Get off easy
It's San Francisco's Watergate

June 2, 1979

THE MAN WHO GAVE AWAY SUNSHINE

He was a tall thin lad
who stood on the corner
of a big metropolis
Hordes of people were
coming home from work
I got Sunshine!
He sang
out into the dark street
Get your Sunshine here!
He sang
Don't cost any money Sunshine!
Anybody got Sunshine!
Sunshine!
I got sunshine!
Anybody Sunshine!
Don't cost any money!
Sunshine!
Sunshine!
Sunshine!
Sunshine here!
Plenty of Sunshine!
As the people kept moving out
into the dark street towards the subways
The tall thin lad
remained on the corner
Sunshine!
I got Sunshine here!
Sunshine!
Sunshine!
Sunshine!
He sang it
I got plenty of Sunshine!
Long into the dark night

POETRY READING
JULY 12

ANN KYLE
JACK MICHELINE

8:30PM
INTERSECTION
756 UNION

$1 DONATION

A PAIR OF BINOCULARS

I could never believe that the world was the way it was
At times there was fear in me
At times I did not believe what I saw,
 for reality is hard to swallow
At seventeen I joined the U.S. ARMY
At eighteen I stole a pair of binoculars
I wanted to examine the world more closely
There were two C.I.D. men waiting,
the morning the ship docked in Seattle
They gave me cigarettes
I refused to make a statement and was sent to the stockade at Fort Lewis,
where I was imprisoned behind barbwire for the first time in my life

The mountains in the Seattle area were beautiful
The tall green pines covered the shores and mountains
The air was fresh and cool
We chopped trees and worked on garbage trucks
 I was to be extradited back to Brooklyn
The fat sergeant in the stockade gave me a hard time
He was a Jewboy also and thought it was a shame that a Jew
should be in jail

 Bullshit lined the face of America

Two M.P.s came and we boarded the train back to Brooklyn
I was put in handcuffs and the journey started
No one will ever know what goes through a person's mind
in handcuffs for three thousand miles across America
The passengers stare at you on the train
The comments, the gossips, the women who feel sorry for you
The shame and humiliation of being called a criminal
The long night in jail in Seattle that never ended
The rattle of the iron door opening and closing behind and above you

Your fellow prisoners moaning, swearing, cursing in the night
The night that never ends
You can see your father cursing you behind barbwire
The self-righteousness of your mother's face
Fear, intimidation, madness, cruelty of so-called humans
to other humans
The judges, the juries, the notes, the court martials,
the barbwire fences of the stockade
The freezing night doing guard duty in Staten Island
The boredom and bullshit of military life

I never could believe that the world was the way it was
At times there was fear in me
At times I did not believe in what I saw,
 for reality is hard to swallow
At seventeen I joined the U.S. ARMY
At eighteen I stole a pair of binoculars
I wanted to examine the world more closely

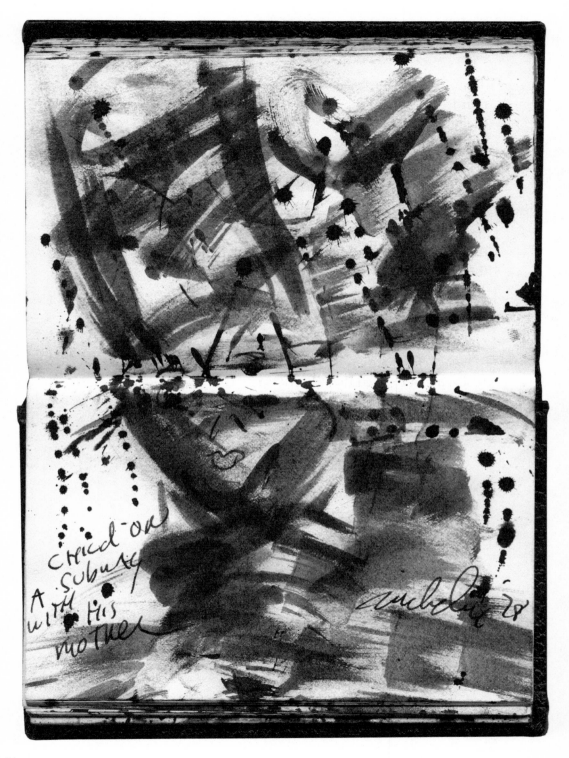

A CHILD ON A SUBWAY WITH HIS MOTHER

WHEN STEEL TURNS TO BUTTER

The war machine melts
away the arms of miss liberty
and empire state

ain't a dream
that steel melts
those machines
well-oiled ships
sink into oceans
the dust of civilizations going down
the bridges linking land and sea
all that, what the process revealed
done disappear from where it came
yet when steel turns to butter
the cars disappear
the guns, airplanes, artillery
mortar, bombs, rockets of destruction
all melted away

the general lost his job
the soldier back to childhood
playing with wooden guns again
wow! what a dream!
wish it happened
and I think it will
when men become brothers
without speeches

A poet's declaration at tables
Let guns
turn to butter
pass the bread around
and the wine
that's a prophecy
written long ago

[A WALL OF MONEY CORRODES MY LAND]

A wall of money corrodes my land
A wall without hope
Like one pigeon
Alone in the grass
No sky
Or tree
Or yellow kite
Flying in the sky
Can change this fact

Where are the poets in my land
Each one is murdered
One by one
By the tongues of silence
The true ones are murdered
Not one lifts a voice against it
Slow death eats
 at the silence
A wall of death
 in my land

The Gobbling Shit Called Man

Gobbling
Rotten
Shitty Man
Was
Chiesler
double dealing
ass Kissing
weeping
Crying
Son of a bitch
Called man
not one
noble inch in him
he sucks and then he kiss
whatever he has he has
betrayed truth
this is the rotten man
The Gobbling Shit called Man

STRUCTURE OF POWER
TOP BANANA

juice
↓
ACTION
↑
JUICE

money	banks	utilities
power	large corp.	transportation
real estate	natural resources	hotels
media	T.V.	
press	magazines	advertising
radio	printing industry	
middle class		
managers	dentists	pimps
engineers	salesmen	
doctors	management	hospitals
art supplies	bars	alcohol
prostitution	soldiers	the mob
masses	weepers	
poets	artists	composers
dancers	writers	musicians

THE TWO CATS WE DONE IN

On the 1929 nickel
America's
morality
and hypocrisy
appears
the two symbols
slaughtered in blood
the American Indian
and the Buffalo
the two cats we done in

MONEY AND POWER

Money and power
is worshipped
and any attempt to censor
the flow of love
free will and intelligence
is against humanity

FUCK GREED!

FIGHT BACK FOREVER!

The indians will have
to laugh at the
white man from
their burial grounds
The hunter will
then be hunted
by each other
The indians prayed
to the sun
and the moon
and the beautiful
Clouds.

[He Painted As A Man Possessed]

He painted as a man possessed
all great artists
are possessed
by forces they cannot control
a poet
cannot control

A poet
opens the heart
as you walk
in early dawn
and dusk
those
are the best times to write
in the changes of light

Be a rainbow
 a rainbow woman
 a rainbow child
Be a potato
Be a prince
Be a mushroom
Be a banana
Be a boss
Be a battleship
Be a airplane
Be a rose
or a violet
Be a monkey
 a monsoon
Be a light

Thinking
is not
the process
of doing

Thinking
can
only
lead
to
doubt

THE LEGEND OF JOAN

I was in my twenty fifth year.
I had just returned from Chicago to Cornelia Street.
Something had happened to me.
I had believed in something very strongly and it had fallen to pieces,
whatever I believed, it failed.
I was shattered with the belief I'd had.
I was like a porcupine. No one could come near me.
I wanted to be alone and I was left alone.
I was like a baby crawling for air in the jungle of the village.
I used to sit in the coffee houses all day just staring into space.
I had only two friends.

One was a huge woman with a great big smile.
She always had a hand out groping for souls. Her name was Lilith.
And a man who was a jack-of-all-trades in a circus in Europe for a
few years. A well-travelled and educated man, his name was Bob.
I used to sit with them and talk and let out my anger as if I had a
large chip of wood on my shoulder. They would talk gently and they
tried to soothe my anger but to no avail.

Out in the streets on a weekend was like a jungle in the village.
People poured in from all over the city and suburbs. They would
scream and yell and curse and make fun of queers and village
characters. They were the nine to fivers let loose in a pack. Given a
weekend of freedom they would go back to their cages on Monday.

It was Saturday night, I walked the streets of the village in a daze.
It was after midnight that I walked up the steps of Pandora's Box.
I walked to the back and sat down.
I sat there for a while not looking up.

Then I raised my head and saw a woman who sat alone up front. A
real deep sadness hung across her face. Compassion and soul were in
her eyes. My head hung limp but some mysterious force lifted me up.
I walked to her table as if she knew I was coming. She smiled at me
as I took her by the hand. We walked to my place on Cornelia Street.

Her name was Joan she said.

There was no electricity in my place because of the poor state of
my existence.
We lit the candles and sat on the floor looking at each other smiling.

A true blessing is a gift from the Gods.

Joan did not speak nor did I.

An understanding had been reached without a word. We slept that
night in each other's arms. We loved as gentle as a dove.
No sounds of hate or bitterness. Birds did sing and flowers danced.

Joan's face were that of angels. She was not beautiful but she was real.
In the morning we got up and went for a walk in the park.
Joan did not speak much but when she spoke every word had wisdom.
When she looked at nature Joan would smile at the trees, the flowers,
the grass.
Most people she laughed at
 as if the human condition of most people
were pre-arranged.

Joan loved life more than any other human being I had known.

That night back in my place she began to shake.
Her expression on her face had changed to fear.
"The Russians are following me!" she said, as she ran out of the room,
down the stairs
 and into the street.
I tried to call her back but it was no use.
Joan roamed the streets that night in torment—torture of her brain
where fear was God.

I did not see her till a week later and she seemed to be alright.
She walked me to her furnished room on Twelfth Street.
She used to live in a small room by a window.
In her room were piles of manuscripts.

Joan was a writer and she would speak of James Joyce and the
influence Joyce had on her.
Suddenly she began to cry.

She began cursing her father who had hired private detectives
to follow her.
Her father was a big newspaper man who was ashamed
of his daughter.
He tormented her life because she was the only daughter who rebelled
against his domination.
She wanted to get a job and it was hard for her.
She said she had passed a bakery the other day and that every one
looked happy working there.
She went in to ask for a job but there were none.
Joan wanted to get her own apartment but she was dependent on
her father for money.
He would torment her and drive her mad and tell her
to come back to Long Island with the rest of the family.

She had left home after high school and went to Chicago University
and majored in literature.
When she graduated school she sneaked on a boat and went to Paris.
There she came in contact with other writers and painters.
She had no money.
Joan lived in the streets.
She loved men because they needed love.
She gave and she received.
She slept with many men.
Joan slept under bridges, in parks, in the subways.
Joan became a legend in Paris.
Her father sent private detectives to Paris to follow and haunt her.
He was ashamed of his own daughter, this self-righteous man who
called himself a father.

There were five children in Joan's family—her four brothers and Joan.
Joan was the only one who rebelled against the wishes of her father.

Her brothers still remained unmarried clinging to the misery of their
family as if it were
 the only thing in the world.

Her father had completely suppressed her brothers but he had failed
with her.
To get even with her he had planned to drive his own daughter mad.

I sat there in her room listening to her speak.
Joan was a great woman and I respected her.
Suddenly she stopped and pointed out the window.
"You must leave! My father is outside in that car."

I left without saying a word
 walking in a daze
 into the afternoon sun.

One evening next week I heard a bang on the door,
"It's Joan! Let me in!" she cried.
She came in, her dress torn to shreds, tears in her eyes.
"Dominic the sculptor tried to dope me with knock out drops!
I threw the glass on the floor and he ripped my dress!
I ran away and climbed the iron fence surrounding his house!"

 Joan wept and
 slept in my
 arms all night.

She kept repeating, a little deliriously,
"I must have a place of my own!"
I took her back to her room in the morning.

There was no doubt that Joan had paranoia and she needed help.
I called one of her friends who would meet me
at midnight the next night.
That night Joan came to my door and it was open.
She slept on the floor next to me since I had no bed.

In the morning we walked in the park.
She spoke of life, and the beauty of life no one saw.
She spoke of birds and trees and grass and flowers.

How beautiful it was

 to remain silent

 and listen

 to the sounds

 of the wind.

The trouble with man was he talked too much
and his senses were closed.
To most people, life was a cell of their own.
The beauty of life was here to be enjoyed!
Through the aid of Joan, she had put some life into me I never had before.
I loved her as a friend.
A close deep friend as long as I lived upon this earth.
No matter how tortured Joan was,
she was more real than most people
I had known.
She had walked the streets of the cities till dawn.
She had been tortured by a fear her father had encouraged.
She had slept under bridges, under trees, in parks.
She had met all kinds of people.
Her mind was rich with the experience of living.
She had written much that would all be published some day.
She had given love without fear, which was the greatest gift of all.
She had given life to the unborn.

"Why?"
I said to myself,
that this woman must suffer so much
pain
 hell
 torture
misery,
when she was able to give life to others.

That night she came by again and was with a short stocky sculptor
named Dominic.
"I love her," he said, panting—"I love her!—Joan, I love you!—I love you!"
he kept saying,
over and over again.
Joan looked at him and said, "You tried to dope me, didn't you?!?"

Dominic kept professing his love furiously.

"Dominic, let's go to Jim Atkins for coffee."
We all went, the three of us.
Over coffee, we argued and fought.
Dominic was a very intense young man who needed love very badly.
He did not love her, he loved himself.

"SHE NEEDS HELP!!!" I screamed, hitting him on the mouth.
"NOW GO AWAY, PLEASE! GO AWAY!"

Dominic finally left.

Joan and I walked up to west 4th street & Charles
and bought four cans of beer in the grocery store on the corner.
We sat there on the curb of Charles and West 4th Street
drinking the beer.
The moon was full,
 the stars shone brightly in the sky.

We sat there and drank beer and talked about life, about poetry I had
written, which
 Joan had encouraged.
We talked about the night and our lives right there on the curbstones.

I looked in her blue eyes and cried tears of joy.
I had known such a woman in my lifetime.

She held my hand and smiled,

 as if she knew what would happen,

that the world
was meant

for

beautiful people.

 The lamppost silhouetted against the tar of streets.

Tourists were walking wobbly on the sidewalk.

The night was alive with two souls drinking beer on the curb.

They looked into each other's eyes and cried right there on the
curbstones.

The air

 was cool,

 I knew this was the last time
 I would see her.

Joan encouraged and smiled at me,

 her mind twisted and tortured

by ordeals
 of her living.

This was the way she wanted to live
and this was her life.

We kissed there in the night and walked away.

Joan went one way and I went another.

Something tells me she still walks the streets at night.

Bringing love to the unborn
 laughing at the moon

with her blue eyes…

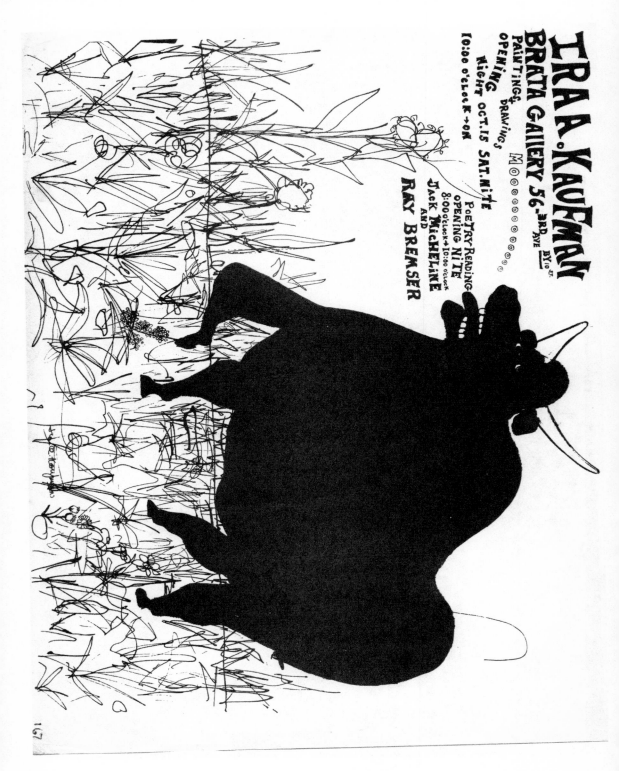

IRA A. KAUFMAN
BRATA GALLERY 56 3RD AVE BY 10 ST.
PAINTINGS
OPENING DRAWINGS
M0000000000
NIGHT OCT.15 SAT.NITE
10:00 O'CLOCK → ON
POETRY READING
OPENING NITE
8:00 o'clock → 10:00 o'clock
JACK MICHELINE
AND
RAY BREMSER

84

O' MOTHER OF LONELINESS

O' mother of loneliness and agony
the heart stops after a long voyage
we who weep with eyes of disbelief
this crime of greed which hovers over the cities
in this night where prayers of mothers caress lost children
in this night I walk without tongue nor direction
in streets of wild horns
in streets of ears and crouched heads
in streets of broken dreams
humanity cries in this Mexican night
this night where humanity is one
in this night where pain reaches down with a frenzy
where the alligator hides in the swamp
and the eyes of beggar children eat the sky
this link across the continents and swords of nations
in this dim light of our age
and let it be said now and forever
that humanity is one always
Yes humanity is one always
I run wild in the pain of cities
let us bury the dead and the darkness
as love waits always for the dawn

[First poem in Mexico City, October 10, 1961]

A SHOT OF LIGHT

The Girls you meet at Poetry Readings

How can it be that I never heard of the guy before
He got up on that stage and blew his ass off
He came out of nowhere that old beat,
with the white hair and bright eyes
"This poem is for everybody!" he said
For the shoemaker and the lonely girl who wants to get laid
For the guys caught in the soup
For the lonely chinaman, the bored waitress,
the hooker on a street
For the cabdriver and the horseplayer
For the secretary and the steelworker
For those afraid to relate, to take a step and then another
Fear always blocking the gates
The gates of fear closed forever

"My poems are simple," he said, "I live them."
To be to do—do it brother—do it sister
Good or bad, right or left, rite or wrong, be aware, be alive, tap in
Don't worry about it
Each one is a separate unit and each is separate and sacred
There are no problems, we carry the bag of shit with us
The shit the parents, teachers, priests and rabbis laid into our heads
Be free and alone the poet sang
Limp gestures, he walked Eromino
A clown's face is a sad face, head down Eromino
Life like a stormy sea
Ah what is this world Eromino!
And so the poet kept walking out into the night
He raised his head
Ain't no way to cry nor ain't no way to fly
Ain't no way to bake sweet sugar and to say bye-bye
Walking on down that long dusty road today
"I'd rather talk than to recite poems," he said
Since I write affirmations, oracles, ballads and chants
All my poems say the same things

Be alive don't be afraid and keep moving
Everyday a new life
Each day a new life
Shine bright! Shine bright! I'm gonna shine bright!
He taps into his own rhythms
Everyone got a song to sing
Everyone got his own sound
"Talk to the moon!" he said
Have a conversation with God
God is the spirit it has nothing to do with organized religion
Each one is God and has the light
Shoot up the light, Shoot up the light
Shine bright, shine bright
He had no P.R. men and most of his life he was scared shitless
Every day's a bonus baby
He remembered hearing that young cornet player in the Village
A smile on that young girl's face in Brooklyn years before
Another poem, another line, another song
All the sounds and faces and smiles and those who could not smile
Maybe he was there years ago head down
unable to dance or sing, unable to cry
"Sing it again baby!" he said
I do it for myself—I do it for those who are unable to hear
Those gone in the dark night
Those murdered by fear or disillusion
Those running away
They who are coming into the light
There's a long road ahead
It's just beginning
The light

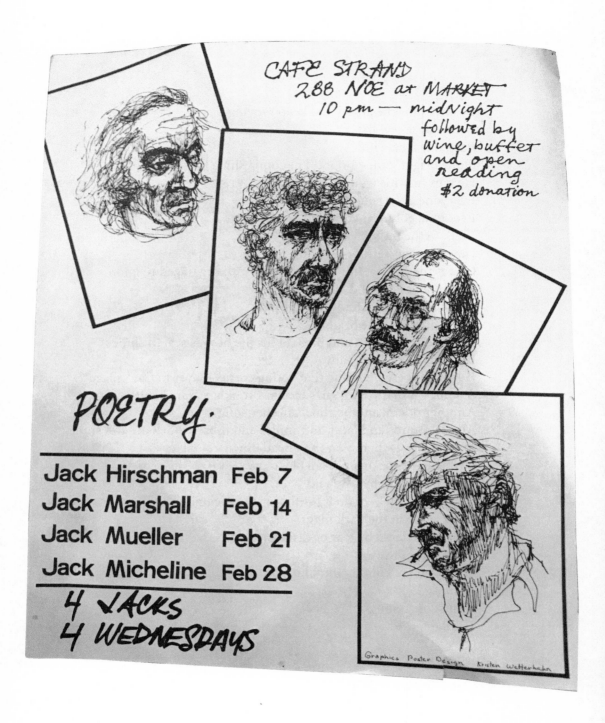

CAFE STRAND
288 NOE at MARKET
10 pm — midnight
followed by
wine, buffet
and open
reading
$2 donation

POETRY.

Jack Hirschman Feb 7
Jack Marshall Feb 14
Jack Mueller Feb 21
Jack Micheline Feb 28

4 JACKS
4 WEDNESDAYS

Graphics Poster Design Kristen Wetterhahn

POETRY FESTIVAL OF LIFE

New Women's Voices

Jon Buckley Laurel Delp Margot De Silva
Claudia Dobkins Ray Freed Peggy Garrison
Harold Goldfinger Alice Hairell Dave Malbin
Jay Mason Taylor Mead Jack Micheline
James McMahon Alicia Ostriker Donald Phelps
Shirley Powell Beverly Sally

SUNDAY NOV. 19 2-10PM
CONTRIBUTION

Broadway Charly's

813 BROADWAY (Between 11th & 12th)

WIGGLE YOUR ASS AND FLASH

Ben, if you want to live a poet's life
don't stay at home jerking off
just slip from your tyrannical
commie dad and go on your own

You're better off dying
in the streets
of New Orleans
 or New York
living a poet's life has nothing
to do with writing poems
living a poet's life
is the beginning
of a real poem
most people just jerk off
with words
They are deaf dumb and blind
all people are shit

Your finger moves
is a poem
a hard on
is a poem
ride a wild cock
ride the wind
obscenity is poetry
dementia is poetry
flashing your ass is poetic
the bug up your ass is a poem
don't be a pseudo intellectual phony
don't be a Jewish nazi punk
they're all jerking off
to the magazines
and newspapers
find your own voice

it is all the lack of
love me
shit
dig me
shit
gossip
shit
all sentimental bullshit
all name sucking shit
keep your own fly door open
be ready for action
wiggle your ass
find the blazing eye
and follow it
till the end

LEE! IF YOU WANT TO MARRY ME
MEET ME AT THE STATEN ISLAND FERRY

LEE!
If you want to marry me
Meet me at the Staten Island Ferry
New York side
Sunday
September 17th
Sunday morning
6 A.M.

If you don't show
It's off

Love,
Jack

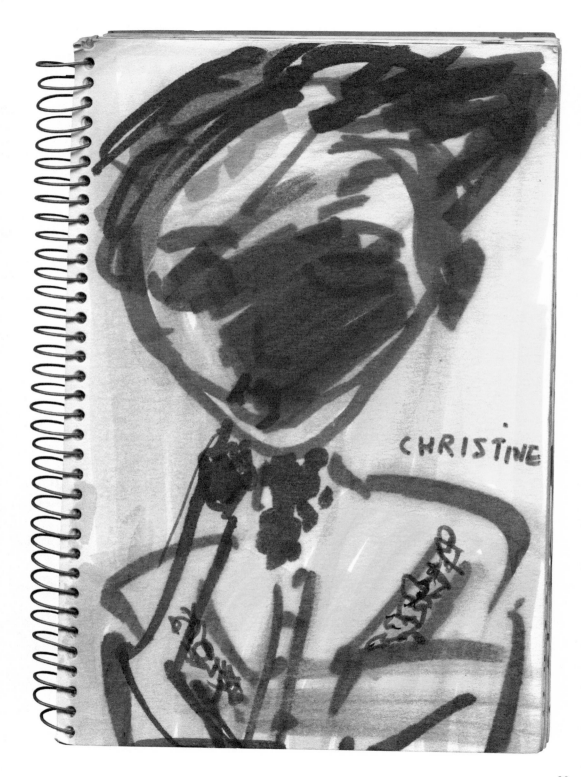

POEM FOR MYRA

You have a wicked tongue
A sweet cunt
and a big soft ass
You can't lose
and I love you

January 6, 1976

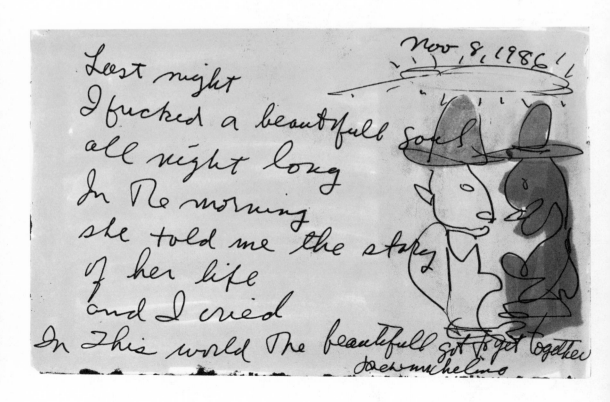

BEAT NO CHASER
WESTCOAST BEATS CONVERGE
Friday, August 22

GLAXA STUDIOS
3707 ▬ **SUNSET Blvd.** ▬
in Silverlake

8pm
An evening of spoken word

presented by (Sic)
Random Vice & Verse

PHILOMENE LONG
JACK ▬ $6.00
MICHELINE
FRANK T. RIOS
TONY SCIBELLA
JOHN THOMAS
HOSTED BY S.A. GRIFFIN

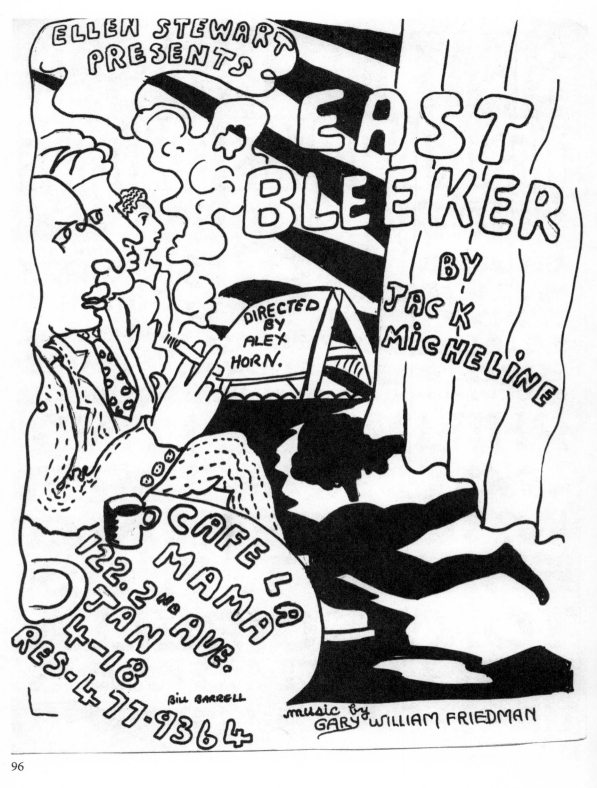

BABA KOOL

Pablo
and Katie
and tequila
and Saint Teresa
and Rafael

Guitar
and songs
and poetry
the turn on
amid the pain
of life
and living
in concrete stone
and spires of a city

Love will sustain us
we hope
but hope is dope now
like a wishing well
in the night
all we got is each other
don't want to be
a patsy anymore

[Art Is An Attitude...]

Art is an attitude
a vision
a reminder man can create
from his reality and move on
to other realms of light, truth
beauty and imagination
when one kicks fear
in the ass
when one opens
his heart
and eye
the cock moves
as well as the stars

[Down To Time Bends The Moon...]

down to time bends the moon
framing mirrors in the darkened room
drawing dimensions to the parting paint
that line the walls and clothes the saint

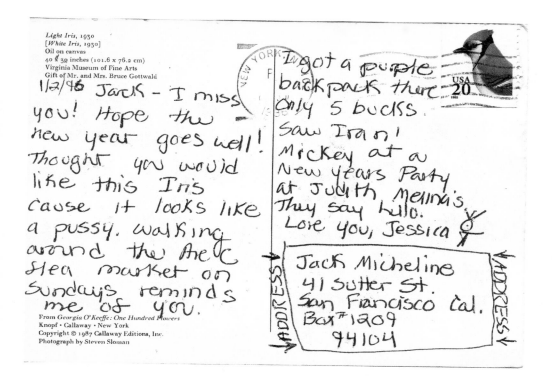

Light Iris, 1930
[*White Iris, 1930*]
Oil on canvas
40 x 30 inches (101.6 x 76.2 cm)
Virginia Museum of Fine Arts
Gift of Mr. and Mrs. Bruce Gottwald

1/2/96 Jack - I miss you! Hope the new year goes well! Thought you would like this Iris cause it looks like a pussy. walking around the AC flea market on Sundays reminds me of you.

From *Georgia O'Keeffe: One Hundred Flowers*
Knopf · Callaway · New York
Copyright © 1987 Callaway Editions, Inc.
Photograph by Steven Sloman

I got a purple backpack there only 5 bucks. Saw Iram! Mickey at a New years Party at Judith Melina's. They say hello. Love you, Jessica

←ADDRESS→ Jack Micheline 41 Sutter St. San Francisco Cal. Box #1209 94104 ←ADDRESS→

Henri Matisse: The Dream, 1940
Der Traum von 1940 · La rêve de 1940
Private collection
© 1994 VG Bild-Kunst, Bonn/Succession H. Matisse
Photo: Archives Matisse

2-2-96 HELLO JACK, Hope everything is okay out there. Its cold here N lots of snow. IM good but broke. I have some book reviews coming out. One is of a book about Gypsies in Europe tHAt i reviewed For High Times. Its called Bury Me Standing.

Also reproduced in *Henri Matisse*, Benedikt Taschen Verlag

© 1994 Benedikt Taschen Verlag GmbH, Köln

I got a used hard cover copy of Last Exit To Brooklyn at your bookstore. I think it was yours. The date is written inside it. Love you Jessica

Jack Micheline, 41 Sutter St. 94104 San Francisco Cal.

99

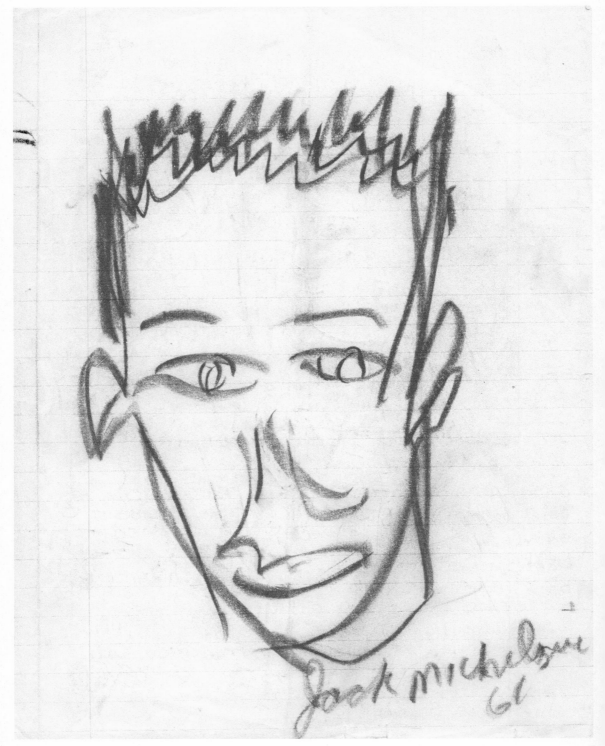

Jack michelson
61

THE NATURE OF GENIUS

When Joel was young he dreamt he would be a writer and an artist. Even though his family had no interest in the arts. Joel had gone through all the phases of search. From the trade union movement to a Kibbutz in Israel.

The most important thing he knew there was something inside of him. Yet it took many years of self-searching before it began to come out. And the writing poured out in the beginning from his twelve dollar apartment in the village where he wrote his first book of poems.

Then he began to believe in himself. Slowly dragging himself out of the mud. He would roam the streets like a wild man at night sometime hungry without food. Most of the time broke. He was an artist who believed in his creation and he was in this belief, alone in his creation. Most artists were egoists. Very few expressed any appreciation for his work. Yet it is blind fate and dreams that make a genius.

It is the belief in his dreams—no matter what pain nor hunger he suffers. For he had brought something new to the world that was never there before—something in his blood that made him burn and go afire. That made his eyes drunk on the city. Drunk on life. For the beauty he saw with his eyes was everywhere.

He had learnt to open himself fully without fear. He had learnt to bare hard winters and loneliness. He had learnt to live in a desert. For the world was a desert where very few people communicated. Only a few friends who believed in their creations and were in the same boat. So he kept on writing and painting for that was his life, to create.

To be one with himself and the world. Some day he would shatter the death and mediocrity around him. Maybe after he would die his work would inspire the young.

Always when he was broke he thought of committing crimes.
In the real crime of the world, they did not care for its true and rare artists.
The world was interested in money and power.
In using the artists for profit and gain.

Somehow Joel would survive and write.
It is hard to be one with the world when the world does not want you.
So you force oneself on the world. You undermine the structure.
By bringing some shattering light to the dark—and say look,
I have created this and if it is good it will stand on its own.
It will fight its way inside you and you cannot deny it.
It is from my dreams, my blood, my cock—my friend this here is
creation, pour like a stream never to die for the source has wings
and many eyes.
In the source of genius is the strongest wind.
It is a dance to end all dances.
It is a beggar with twenty dimes.
It is a disease that spreads through the world.
It is something created from blood and sweat and tears.
Some inner force that buries darkness.
Here, world of mediocrity and war and politicians and beautiful
speeches and academics.
I show you this creation is more alive than you.
It is the source of all change.
It is a breeder of hope and inspiration.
The children shall know it.
The one eyed men—the damned.
Genius is a crime and the sentence is poverty, persecution, denial,
hunger, insanity, but above all, it is triumph,
over a world bent on self-destruction.
Bent on the destruction of genius and the rare individual minds.

POEM ON MY 39TH BIRTHDAY

Working as a second cook
In a cafeteria uptown
$14 a day
Another year
3 scotches after work
43rd floor overlooking the east river
The U.N.
The City
You dead souls work here
No one laughs
Man gone

65th BIRTHDAY NYC

When I came back from New York
In December 1995
I was tired after 40 years
Of roaming my ass across this nation
On my 65th birthday in New York
I walked across the Williamsburg Bridge
And made believe
I was my Grandfather
Walking across Poland
In his childhood

Grandfather
LOUIE SILVER LIPINSKY

November 6, 1995

Hi Jack, got yr letter of Oct 9. Stacy Lewis, the publicist at City Lights, set up a reading for me and you at North Beach Library November 13 5 to 6 PM. Gardner Haskell, librarian. I thought, I'll read from bk a poem or 2, you can read from new bk, & like that. Do you want to do it. Let me know. Take care of yrself. I'm looking forward to seeing you. Love, Janine

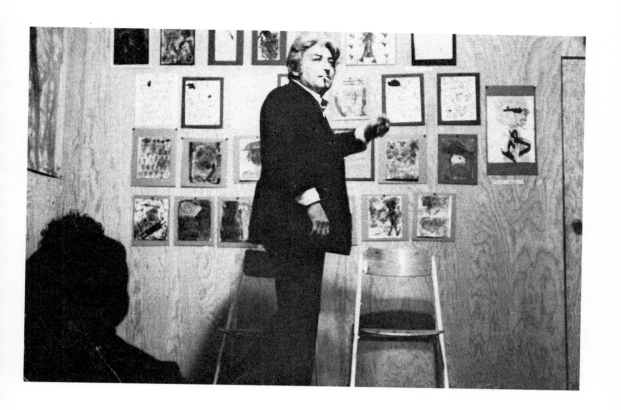

THE DESTROYER OF A DREAM

It seemed he was born in a world where he did not fit
He generated so much light that he frightened most people
He was a sensitive boy who lived a wild, relentless life
He had known the cruelty of other men in his youth
He did not believe that man could be that cruel
He wrote poems and wandered about the city drunk on life
He was able to see beauty because beauty was inside him
Drained of his energies at times, weak and wobbly,
torn by a world of indifference to creation and truth
He continued on his journey a long lost youth,
who frightened a world of fear
He sought the kind face, a beaten face, an honest face
He wanted to blow a trumpet out of his skull
He blew the darkness into flowers

In his journey he met the beautiful people of the world
Torn, beaten, hungry and alive like himself in the darkness of cities
He was born into a world where he would never fit in
He had no other choice than to keep going on, being himself,
the destroyer of a dream and darkness

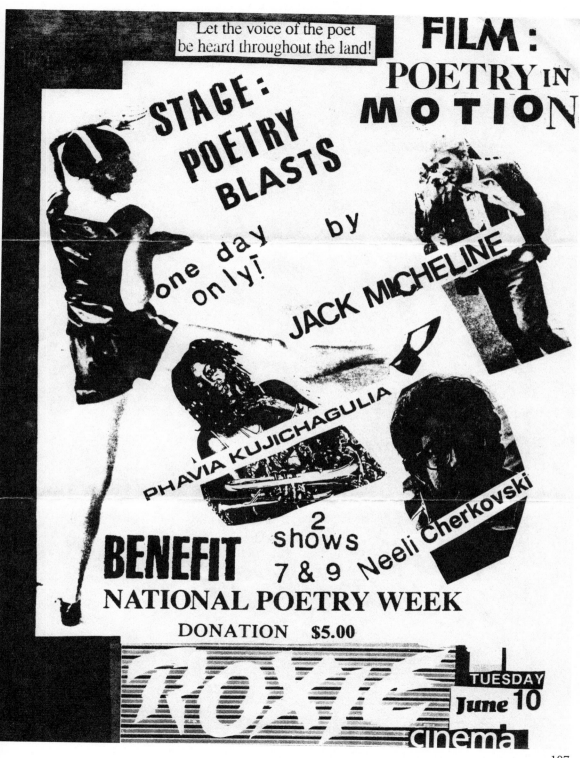

Let the voice of the poet
be heard throughout the land!

FILM:
POETRY IN
MOTION

STAGE:
POETRY
BLASTS

one day by
only!

JACK MICHELINE

PHAVIA KUJICHAGULIA

Neeli Cherkovski

BENEFIT 2 shows 7 & 9
NATIONAL POETRY WEEK
DONATION $5.00

ROXIE
cinema

TUESDAY
June 10

Poem

on Market Street
It is approaching dawn
Such a wondrous Sky
Grey clouds
and there beneath
all I knows
they killed kid warmth
kid warmth is dead
takea leak
on a rich mans foot
do not be ashamed of it
Such a wondrous Sky
air Belongs to All
the People
In oaktown

16TH ST. BART

walking up and down
like a wild panther
at the 16th St. BART Station in the Mission
the truth will not make you free
brotherhood is a dream long gone
the market place
where slaves were sold
one hundred thirty years ago
is still there
humanity living
by its balls forever
cars and cats
and wash line rainbows
fruit markets
diners
coffee houses
laundromats
every color of the rainbow
bible salesmen with suits and ties
anti-war tactical squad
helmets and truncheons
against dreams and flowers

you want to be good
in the world
forget it
give everybody a piece
of my action
the greedy one cannot sleep
hasn't enough
everyone wants free gifts
these hands are stretched
not coffee for diamonds
not pearls to swine
bright lights

to impress
the gullible
extra power
to make everything good and lost
the ones with too much
can't wait fast enough
to give it away
for a work of art
for a piece of jewelry
or a shrink
for a tax deductible grant

hidden away in dingy hotels
for two long miserable years
a sly fox
an old beatnik
a teller of tales
down for the count
talking to himself
in a closet of dreams

outside a family of junkies
the ringleader mother
pickpocket son
hustling skin and daughter
for a fix

wild eyes
old man with cane
Spider the cotton picker
O'Leary from Dublin
Moose formerly from Alcatraz
Jimbo his toothy smile
is a bike messenger at 41
Hit the Big Six for $50,000
in 1989 when
Ambence went 1.07 & 4/5th
to break the track record

Jimbo smooth, cool, wild
also a nuthouse graduate
I like his wild laugh
you can't put Ireland in America
America absorbs everything
Greeks
Bulgarians
Poles
Dutch
Italians
Germans
Puerto Ricans
Mexicans
Vietnamese
Indians from India
All of South America
Chinese
Japanese
Koreans

they will teach us to pray
they will send us to school
and will not teach us
what we need to know
who is man
who runs the show
who owns the real estate
who owns the teachers
did the horse sleep well
why the fat guy can't sleep
young girls dream with beautiful eyes
children play and laugh
jump rope and giggle
the sky turning grey to blue
the puritans killing
indians and buffalo
preachers getting their jollies

good money to be made
on war, whiskey, cigarettes, whoredom
good money is the dollar bill

sell medicine
sell moonshine
sell the monkey on a stick
sell panties
sell ties
sell corn syrup
sell wood
sell bullets
sell muskets
sell the blue
sell the grey
sell hot dogs in football stadiums
sell

© REPRODUCTION OF ORIGINAL LINOCUT. "PORTRAIT OF HAROLD NORSE" BY PETER LEBLANC. 1973

BEATITUDE READING OF SAN FRANCISCO POETS

LAWRENCE FERLINGHETTI JESSICA HAGEDORN

BOB KAUFMAN NEELI CHERKOVSKI

HAROLD NORSE DAVID MOE

ANDREI CODRESCU JACK HIRSCHMAN

JACK MICHELINE KRISTEN WETTERHAHN

ROBERTO VARGAS WAYDE BLAIR, GUITAR

LITTLE FOX THEATRE
531 PACIFIC AVENUE

8:30 P.M. MONDAY FEBRUARY 9, 1976

$2.00 ADMISSION

ADVANCE TICKETS — CITY LIGHTS · SAN FRANCISCO CODY'S BERKELEY

POETRY SERIES
KEYSTONE KORNER
750 VALLEJO STREET, SAN FRANCISCO

© TOM ROBINSON 1980

JACK MICHELINE HOWARD HART
DAN PROPER

SUNDAY, APRIL 6 4 PM ADMISSION: $2.00
FULL LIQUOR BAR MINORS WELCOME

INFORMATION: 956-0658
PRODUCED BY TODD BARKAN & BEAR WILLIAMSON

IN A PARK OFF UNION STREET

I am getting old and tired
hiding again from the world
A maze
A blaze
In a dark cave
In a desert
Maybe it is the ones that still feel
That are the only ones that understand
But there are too damn few of them
Too few who have been on the mountain

I am not a man of the cloth
Nor do I wear a business suit
And it is hard to write love letters
And hope I communicate
To some lost soul
Here on this earth

Anger kills the mind
And swells up in the body like a cyclone
And love strips us of our armor
And makes us weak like little children
It is better to be a child
With a blazing flashing eye
Inspired by the sun
Than a mediocre hack
Drowning in self pity and theft
Accepting the empty roars of the crowd

Then I shall inspire the young
If I inspire them in my lifetime
I HAVE INSPIRED THE WHOLE WORLD!

REPLY TO A PERSONALS AD IN THE S.F. BAY GUARDIAN

You people are living in the past
My work is for the future

You sit around the same table
at Specs' every night
drinking the same gallon of red
I climb the mountain to the source
of the cold clear stream
and let its ever newness refresh me

You dream of imagined injuries
committed in a world
that no longer exists
I study what is beautiful
about the ways
that humans make connections

You are released
I release you
Where the great pain gnawed
there is no wound

San Francisco
October 23, 1986

The Erotic
Note Book
of Jack
M. Kelvin'
put together
Jan 1, 1996
San Francisco
at 3:20 AM

Jan 1, 1998

ZULU STYLE

A form of lovemaking without penetration which young warriors and unmarried girls were once permitted in a traditional ceremony known as 'the wiping of the spears.' The young man could move his 'spear' to-and-fro between the girl's labia until they both achieved orgasm, but was not permitted to enter her. The success rate of this broadminded though precarious solution to the problems of adolescent sexual frustration may be judged by the fact that the greatest of all the Zulu kings, Chaka, was conceived during just such a ceremony

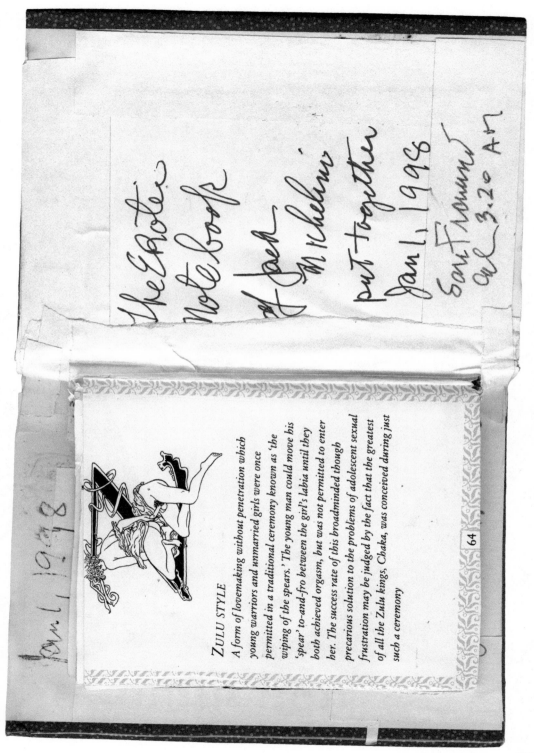

64

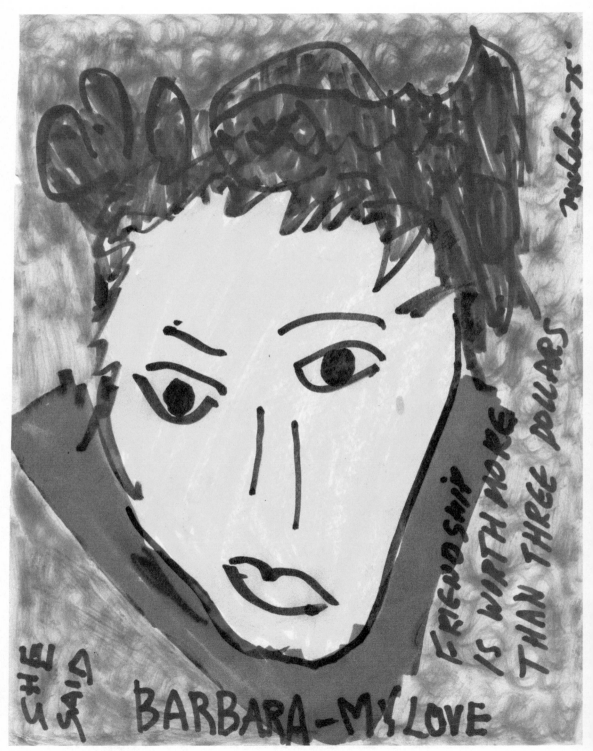

118

WANT A KING SIZE BED

Saved my money
Stole the sheets
Want a king sized bed
Want to be immortal
But I'm not commercial
Want a king sized bed

Cost 199 dollars
Cold hard cash
Want a king sized bed

Gonna find me a queen
To put in my bed

AS THE SUNLIGHT FADES DOWN ON HOWARD STREET

As the sunlight fades down on Howard Street
the moon will come out and sing a song
Sometimes winds don't dance
and voices boomerang with pain
Sometimes I want to walk in the sky forever
Singing a Cajun lullaby

Dear Philip Hackett: Please tell Jack I'd be very interested in reading with him in L.A. ... if that was the intent of your message. I haven't read anywhere in a few years tho, I am out of touch with those currently putting on readings.

I've always had a warm feeling for Jack — I was the very first person to speak to him when he arrived in North Beach in the Beatitude days. He was sitting on a curb on Grant Ave, writing! No one else had noticed him.

best, Will Margolis

DATE: _____ 10-9-85

YES, I'M (WE'RE) INTERESTED!

PLEASE CONTACT:

NAME: _____ William J. Margolis

AFFILIATION: Poet & Mendicant

ADDRESS: 1507 Cabrillo Ave
Venice, CA. 90291

TEL. NO.: (213) 399-0040

28 harwood alley sf
94133

JACK MICHELINE
VIKING HOTEL
1878 market street
san francisco, ca

jack: i know how you distrust praise, but i did have to
send this off to you. rd the poems all and i see what a
major slice of this apple pie you've been able to take
without a lot of people noticing. im so tired of cerebral
poetry and the poetry of the pousseur. i really see how
that article of mine (which so many distrusted) really
was right on target and how you fall directly in the
villon path.
so i told you thankyou the other night at the party and i
do so once again. whatever i am as a poet is cause of peo-
ple like you and harold and hank and some thirty thousand
or so others...i hope i can go on as you have---let us
sing a song...

 NC

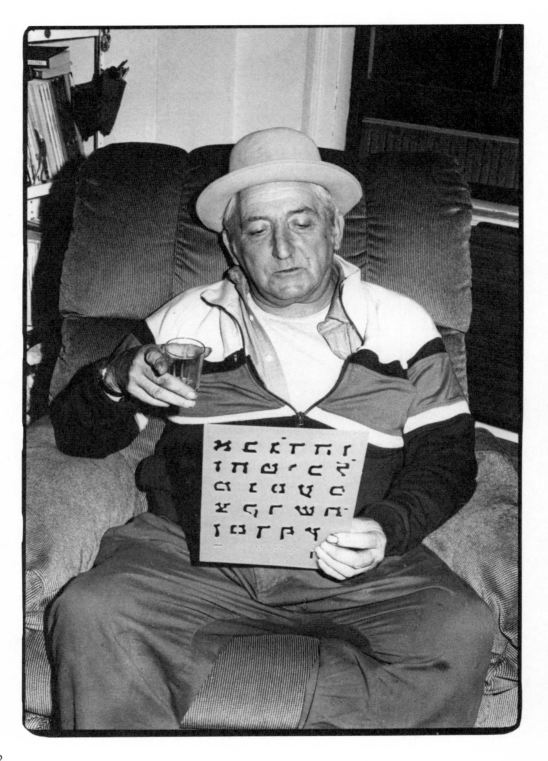

CULTURE IS DEAD

In all the city streets
and all the towns
I sing my songs
for all to hear
dead ears listen
nothing penetrates
only an echo on a wall
that is all it is
culture is dead
dead echoes on a wall

FAREWELL TO SAN FRANCISCO

No more
The blue sky
The early morning sunrise
No more to the beggars of the street
No more Adobe Book Shop and the Abandoned Planet
Goodbye to Henry Hollander
Goodbye to the Busy Bee
No more to the silence of the streets
No more to the beautiful eyes
Of the child on the bus
No more to the dreamers
No more to the shaking thighs of young women
Goodbye to the photos and Katz's Bagels
Goodbye to Coit Tower and North Beach
Goodbye to Bob Kaufman and Jimmy Lyons
Goodbye to Tony Duncan and Willy the Cook
Goodbye to the Uptown Bar
Goodbye to the Streets of the City
Goodbye to the hookers on Capp Street
Goodbye to all

August 17, 1994

PUNKS ON MARKET STREET +

GREASY SPOONS: (CHINESE RESTAURANT)

STREET PEOPLE
BANKS
LIQUOR STORES
BAR ROOMS
RESTAURANTS
MOVIES
GROCERIOS .
CASH REGISTERS
(COFFEE SHOPS
BOOK STORES

HOOKERS
DRUG ADDICTS
HUSTLERS
SCREAMING .
BANGERS
WEEPERS
WAX MUSEUMS
ART GALLERIES
FRUIT STORES

PUNKS
PICK POCKETS
PUSHERS
PIMPS
BEGGARS
PREDATORS
PILL FREAKS

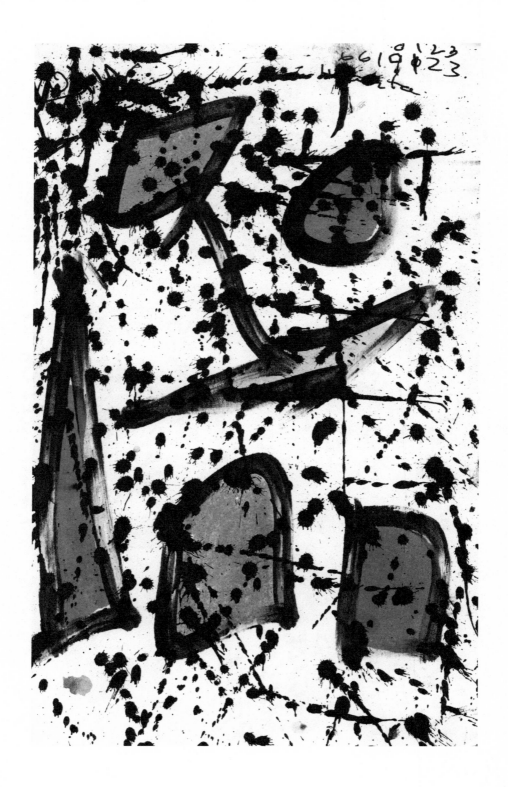

126

POETS EPITAPH

Who am I
I am a poet
I am beyond time
Mock me
Shun me
And bury me
I am beyond time

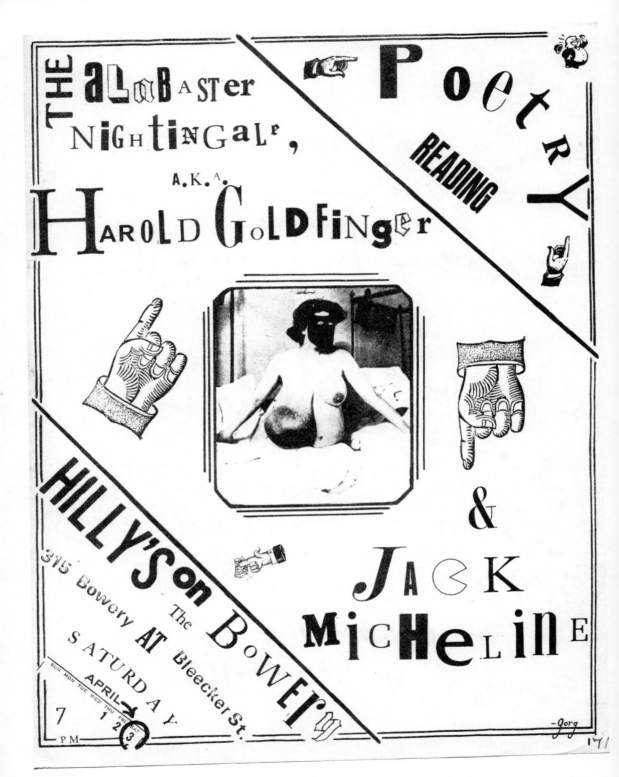

THE ALaBASTer NIGHTINGALe,
A.K.A. HAROLD GoLDFiNger

POetRY READING

HILLY'S on BOWERY
315 Bowery AT Bleecker St.
The
SATURDAY
APRIL
7 PM

& JACK MICHELINE

-gorg
'171

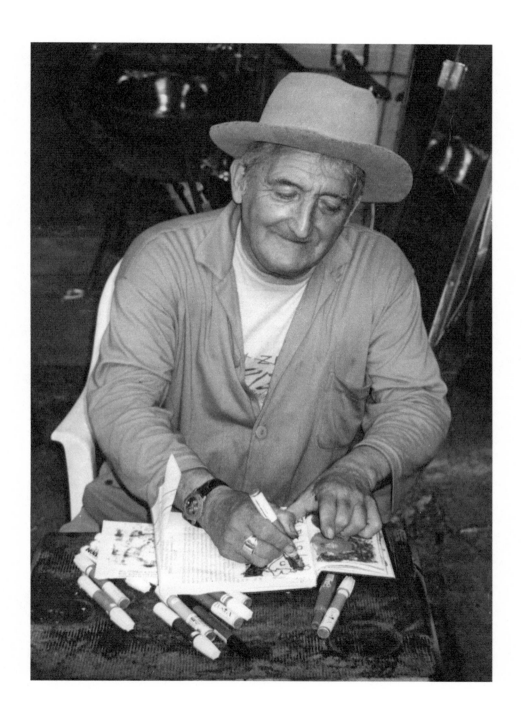

INDICA
Books
& Gallery

6 Mason's Yard
Duke St St James
London SW1

23rd March 1966

Dear Jack,

enclosed a cheque for you. Sorry its in
pounds and everything but we havn't completed
arrangements with a New York bank yet. IN THE BRONX
has been going quite well here, which is great
considering we have only been open just over a week.
How are things in New York on your scene. The only
people I am in contact with are the East Village
Other (who I write a column for) and the Ed Sanders
group, Ed, Tuli, Betsy, Joan, et all. Also the
Warhol Malanga axis. Are you doing any readings?
Do let me know if you publish anything else because
I'll certainly take copies for here.
Best wishes.

Miles

ps. Sorry this letter is so short but I have to write
about 30 letters today and this is 17th.

130

AFTERWORD

The seed that sprouted this book was planted on February 22, 2018 at City Lights Bookstore. An event took place celebrating a reissue of Allen Ginsberg's reading of HOWL! on vinyl. Garrett Caples, a poetry editor for City Lights, was scheduled to speak but unable to attend. He asked me to fill in and say a few words about poetry on records. This due to the fact that I've released records by Beat Generation authors like Herbert Huncke, Harold Norse and two separate records of Jack Micheline.

After the event I was across the street sitting in Specs', a bar located in the cul-de-sac renamed William Saroyan Place. The night was peaking, and after a couple pints of Guinness, I was feeling flush with the flow. I dashed across Columbus Avenue and back into City Lights. Peter Maravelis, Events Director, was folding chairs and restoring order to the main floor of the bookstore. Upon gifting Peter with a copy of a Micheline album we began discussing Jack's legacy. I mentioned a vision about digging into Jack's archives--that his son Vince Silvaer has diligently stored in Tucson, Arizona—and compiling a book of previously unpublished writings (Julien Poirier attempted this but time constraints were a hindrance). Peter encouraged this notion, even tossing out names of presses that might publish this book.

Within days I was on the phone with Vince who matched my enthusiasm. Six weeks later I was flying into Tucson. The next morning Vince escorted me to the storage unit and the work began. Jack Micheline kept everything. As I dug thru journals and notebooks the other ephemera spilled out. A medium-sized box crammed full of napkin drawings and poems was begging to be unsealed. As I began unfolding and photographing these scribblings a grander thought entered. This book is the result of such grandiosity.

As an extension of the open-heartedness and spirit of comradeship that Jack Micheline strolled the streets espousing, Vince and his family welcomed me with warmth and love that still resonates. Twice they opened their home and allowed me to commandeer the formal dining room table for an office. Much gratitude to the Silvaer family!

I returned earlier this year with a proper scanner to capture high quality images just in case a publisher would agree to include these vibrant expressive drawings, flyers, letters and the rest.

Driving out of San Francisco, the day after Lawrence Ferlinghetti's 100th birthday, I was running on fumes but rejuvenation arose upon pulling into Los Angeles for a pit stop at the home of S.A. Griffin. Not only a fine actor, poet and keeper of many flames, S.A. was a great friend of Jack's. He provided sustenance and support that won't show up in the box score but without such encouragement these projects do not cross the finish line.

Another good friend to Micheline, Neeli Cherkovski, recommended sending the manuscript to Lithic. Not only did he suggest this but minutes later handed off the phone and Danny Rosen and I were discussing the details. Danny wanted to know more about my "ultimate dream," for the book. Once again the muses rewarded the work as Danny's avidity lit the fuse.

Like any great cleanup hitter Kyle Harvey stepped in and cleared the bases. Within hours of sending the scans he counterpunched with a mock cover, a TKO, that is what you see up front. It's these little moments, along the way, that lets one know they are fully in the flow, the project showing us the way.

When I first began this project I knew that Eric Mingus had to write the intro. I can still recall, that day in midtown Manhattan, Eric graciously stepping away from work to record some words for the tribute album to Jack. Right off the bat I felt at ease, especially when he didn't hesitate to correct my positioning for the audio. Artists share knowledge and tho we're a sensitive bunch we must remain open to such input. Eric's affection for Micheline's mentoring remains in my ears as I encounter artists far and wide. We create art to share our unique perspectives and none of these should be censored, silenced or repressed. All should be free to sing their songs!

The first Micheline record I put out was a reissue of a cassette tape recorded in Amsterdam in 1982 and released by Eddie Woods. Eddie has been an invaluable mentor, confidante, editor and all-around no-bullshit New Yorker.

With Eddie's eye and ear in mind, I tried to barely touch Jack's words in editing this volume. Mostly format changes as Micheline liked to write in single-spaced lines that ran together, sometimes punctuated, sometimes not. The majority are as is but the most liberties I took are with the story THE LEGEND OF JOAN.

A quick note on the letter from Barry Miles: Vince's son, Dustin, discovered an interview, recently posted online, from September 1966 between Paul McCartney and Maureen Cleave (the journalist who quoted John Lennon saying, "…we're more popular than Jesus now.") McCartney arrived at the interview with a recent purchase, IN THE BRONX AND OTHER STORIES, by Jack Micheline. Posting this interview online caused the book to jump to #18 on the most wanted out-of-print books. Earlier this year, due to such high demand, this book was reprinted with an introduction by Vince Silvaer.

Lastly, big thanks to brother Todd for typing up poems and lending eyes to decipher the various scrawls and scribbles! Shout-outs to Matt Gonzalez, Win Harms, Sean Linezo, Yuko Otomo, Julien Poirier, Brontez Purnell, Scott Satterwhite, ruth weiss and Hannah Woods. Artists and activists that keep my blood pumping!

LONG LIVE HAROLD GOLDFINGER!!!

Tate Swindell
San Francisco
May 1, 2019

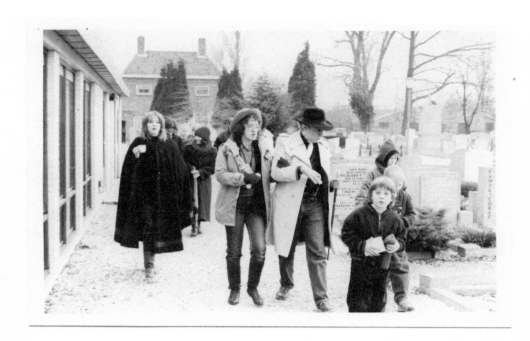

dean Jock *(from good Transparencies (slides)* (13.10.87)

MUCH LOVE

Kali, Inc. presents

HONOR THY WOOF
The Snuffie Memorial Exhibition

eddie (& the Woof)

et al.

Surreal photodocumentary of the funeral, on Ash Wednesday 1987,
of The Gangster Woof of Amsterdam.

*There ain't another One to get (and you
know what I mean); plus I've already
got a very good woman. Am still hot-to-
trot to do Micheline postcard — proper size,
thicken paper, etc. How 'bout The 'horsies'?
Pls send samples of all you've done (postcards)*

Private showing. Honor Thy Woof can be viewed, by prior arrangement,
at Ins & Outs Press, O.Z. Achterburgwal 169, Amsterdam. Tel 276868.
Or write to P.O. Box 3759, Amsterdam, The Netherlands.

SNUFFIE is still watching...

BIOGRAPHIES

Jack Micheline was born Harvey Martin Silver on November 6, 1929 in the East Bronx (New York City) of Russian-Romanian ancestry. He changed his name legally in 1963, choosing "Jack" after Jack London and "Micheline" as some purported adaptation of a family name.

His first travels started at age seventeen. A voyage to Israel, in 1949, brought him to the Negev where he worked on a Kibbutz.

He began creating and publishing work in 1954 and soon moved to Greenwich Village. In 1957, at the Half Note Café in the West Village, Micheline won a poetry reading contest, the "Revolt in Literature Award," judged by Charles Mingus, Jean Shepard and Nat Henthoff. The prize consisted of ten dollars worth of jazz albums from Mingus' "Debut" record label. In 1958 his collection *River of Red Wine*, which boasted an introduction by Jack Kerouac and garnered a favorable review from critic Dorothy Parker in *Esquire* magazine, established Micheline as a writer.

He was most influenced as a painter by the renowned abstract expressionist, Franz Kline. Through Kline's friendship and generosity, Micheline received moral and financial support to begin painting in earnest. In 1961, Kline gave Micheline $3,200 to travel to Mexico to further explore his artistic aspirations. While there, Micheline became an active painter adopting his trademark colorful, childlike primitive-style.

In the early 1960s Micheline traveled to Europe, across the United States, Mexico and Israel. He lived in rooming houses, stayed with friends and got in touch with other underground artists. In 1962 he married Patricia Cherkin of Monessen, Pennsylvania. With this marriage he had his only child, Vince Silver. The marriage lasted 1 year.

In 1964 he married Marian Elizabeth Redding, a politician's daughter, and went to Europe with her. Just a year later the marriage broke up.

In 1968 John Bryan, the publisher of Open City (an underground Los Angeles newspaper) was arrested and charged with obscentiy for printing Micheline's short story, "Skinny Dynamite." Many prominent writers, such as Allen Ginsberg and Hubert Selby Jr., wrote letters of support to defend the literary merits of this controversial writing. The case was eventually dismissed thanks to legal assistance from civil rights attorney Stanley Fleischman.

By the late 1960s Micheline had relocated to the West Coast, settling in San Francisco permanently in the early '70s, where he was a local figure in the North Beach art scene. He became acquainted with west coast artists including Charles Bukowski, Ken Kesey, Bob Kaufman and ruth weiss with whom he had very close friendships.

In 1969 he began self-publishing books in limited editions of 10 or less or up to as many as 100. These were usually hand-bound in folders held together by staples and mimeographed at the local copy store.

Throughout his adult life, he joined liberal causes and criticized the oppressive elements of government that enforced censorship or tacitly accepted racism. He identified with the disenfranchised and downtrodden encountered in his travels and learned to love the sounds of jazz and the liberation of painting and poetry. His work possesses a natural rhythm and rhyme which connects with an audience whom has little interest in, and contact with, the arts.

Jack Micheline died on a San Francisco BART (Bay Area Rapid Transit) train on February 27, 1998 of a heart attack. More than two dozen books, or booklets, were printed in his lifetime, numerous broadsides as well as several dozen antholgies in which his poetry was featured.

Archivist, Poet and Photographer, **Tate Swindell** is the founder of Unrequited Records, which specializes in poetry records released on the vinyl format. The latest release was an album of rare Gregory Corso readings from the late 1970s that included previously unpublished poems. In addition to an album of rare Bob Kaufman recordings due out in 2020, he recently co-edited the Collected Poems of Bob Kaufman for City Lights Books (2019). Tate, and his brother Todd, worked extensively on the Harold Norse archives, which were donated to the Bancroft Library at UC Berkeley. He is currently writing a memoir about his experiences as a pioneer in the San Francisco medical cannabis movement. His previous collections of writings include *Palpitations, The Creation of Deadlines* and *Fotopomes.*

"operatic, unhinged, punk and terrifying"–*timeout.com* ... **Eric Mingus** is a bit of a polymath when it comes to his music. Trained classically as a vocalist, he sings the blues like nobody's business, improvises with the best of them, and plays a fierce bass. Creates worlds with his words whether he speaks or sings. When famed producer Hal Willner needs that special moment in his multi artist shows, he calls Eric. Hubert Sumlin loved the way Eric brought "soul" to the blues. When Elliott Sharp wanted a vocalist for his project Terraplane, he knew Eric was the right voice to bring the contemporary blues to his musical vision. Eric has a unique sensibility when bringing music to film, and has scored two documentaries on boxing for ESPN. His passion to write and perform poetry was encouraged by the likes of Allen Ginsberg, Jack Micheline and Lou Reed.